OUR SHOES OUR SELVES

*"IF THE MEN SEE
YOU JUMP,
THEY WON'T DARE
CHICKEN OUT."*

—AS TOLD TO FOUR-STAR GENERAL ANN DUNWOODY,
BEFORE HER FIRST PARATROOP JUMP

Dedicated to Eloise, Annabel, Maeve, Clare, Mabel, Ellen, Alice, Katie, Phebe, Georgie, Violet, Erela, Ella, Drew, Rosie, Lutéce, Isabel, Wilhelmina, and all the girls and women out there who have a dream but maybe don't know how to take their first step. Hopefully some of the footsteps we trace in the following pages will show you that you aren't alone and also inspire you to forge your own path.

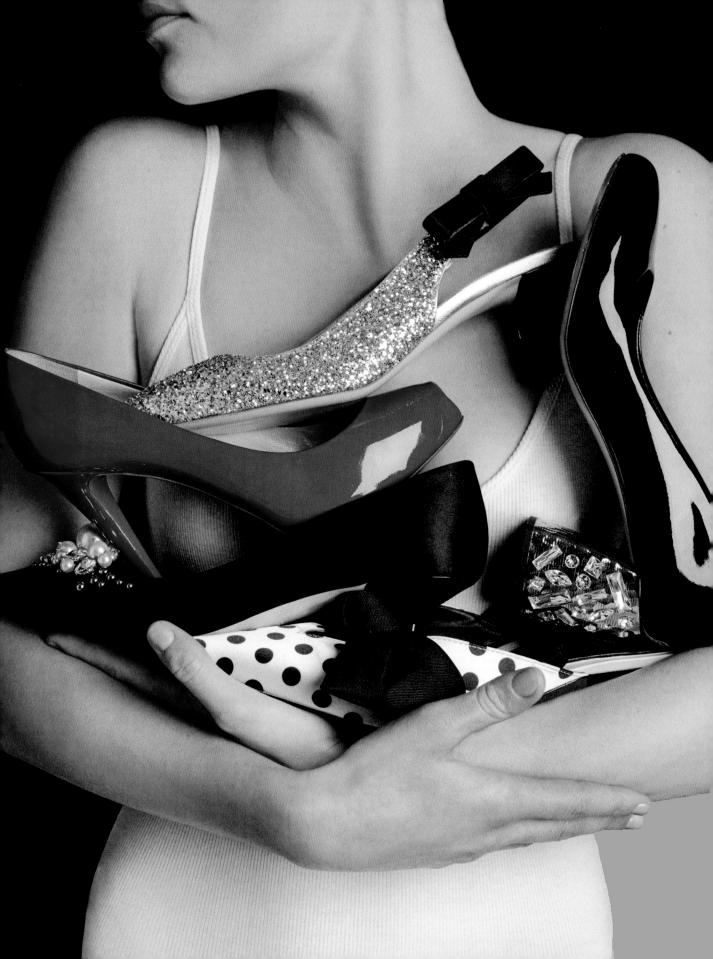

OUR
SHOES

40 WOMEN, 40 STORIES, 40 PAIRS OF SHOES

OUR
SELVES

BRIDGET MOYNAHAN & AMANDA BENCHLEY

PHOTOGRAPHY BY MELANIE DUNEA

ABRAMS, NEW YORK

CONTENTS

INTRODUCTION

T his project all started with cleaning out my closet. I had done it so many times and moved shoes back and forth to the storage unit. This was the year I finally had enough. Why was I keeping them all? I was never going to wear them again. Hell, I can't even fit into most of them of them anymore!

I started making a pile of the ones I wanted to donate . . . and I found that I kept taking them out of that pile for one reason or another. Each pair had a memory attached to it. Some I wanted to cherish, some I wanted to forget . . . but they all had meaning from specific times of my life.

I didn't want to continue to pay New York City storage unit prices for a bunch of shoes that I would never wear. I also felt that they were all soooo gorgeous that someone else should be wearing them. So why not photograph them? I thought this could be a fun project but realized fast that . . . it's not the shoes that mean anything, it's their stories. And if my shoes have stories . . . I bet a lot of women have even better stories! So I called my friend Amanda.

—BRIDGET MOYNAHAN

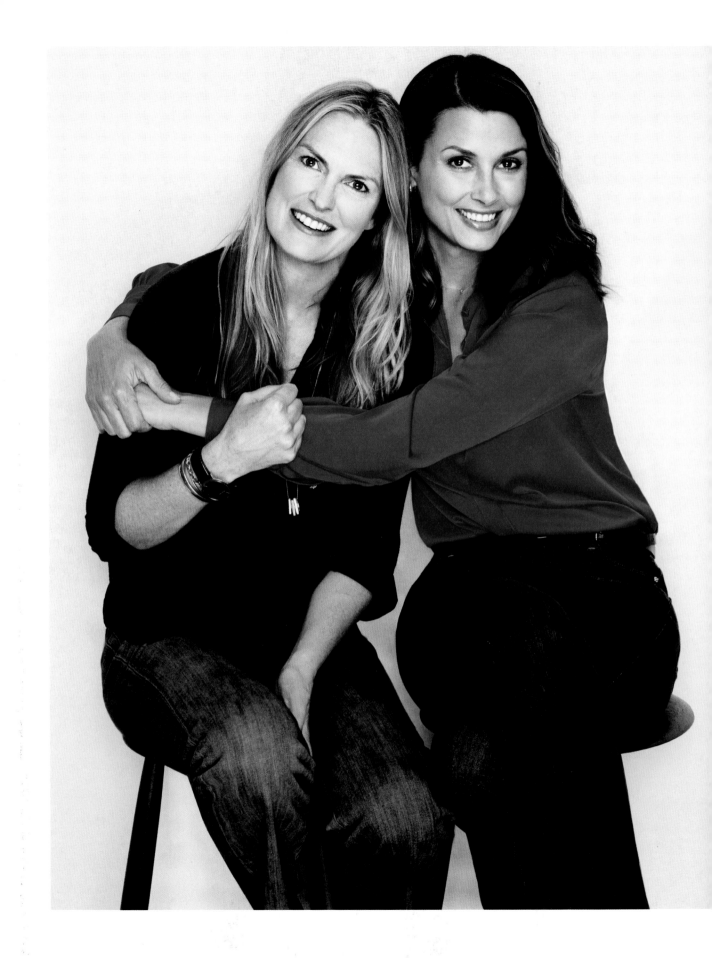

"TURNS OUT, IT WAS NO WONDER THAT CINDERELLA FELT SO TRANSFORMED WHEN SHE PUT ON HER GLASS SLIPPERS. SHOES CAN CHANGE YOUR LIFE AND, EQUALLY IMPORTANT, YOUR SELF-PERCEPTION."

I WILL NEVER FORGET sitting in a taxi on my way to dinner, when I got a text from Bridget: *Cleaning out my closet. Why can't I get rid of some of the crazy shoes that I never wear anymore. Is there a book there?*

We talked about the idea and some of her favorite shoes, and soon a story emerged about how an emotionally trying time led to her pair of black Miu Miu motorcycle boots. I then looked at my own shoe closet and found my pair of gold Gucci loafers. I had first seen them on two talented, inspiring women I knew at a small dinner party. I bought them for myself and for my good friend who had been the host of the party and declared them the Sisterhood Shoe. Two other friends quickly bought them as well. Those shoes make me appreciate my sisterhood of friends every time I wear them.

And that's how we discovered what this book was about. Turns out, it was no wonder that Cinderella felt so transformed when she put on her glass slippers. Shoes can change your life and, equally important, your self-perception. So, with this concept in mind, Bridget and I drew up a dream list of women whose shoes we most wanted to see and whose stories we most wanted to hear: teachers, politicians, scientists, entrepreneurs, athletes, marine biologists, coders, and writers, to name a few of these inspiring figures.

So many women from our dream list agreed to participate. In the past year, I interviewed nearly every woman in this book. Often these interviews were so moving and powerful that I ended up crying. I have told most of these stories in these pages, trying to stay as true to their owners' voices as possible. Some of our participants wrote their own stories, which was a tremendous gift to this project. As you will see, each shoe has a story—a story of accomplishment, challenge, glory, triumph, transformation. Memories. We invite you to come along on our journey.

—AMANDA BENCHLEY

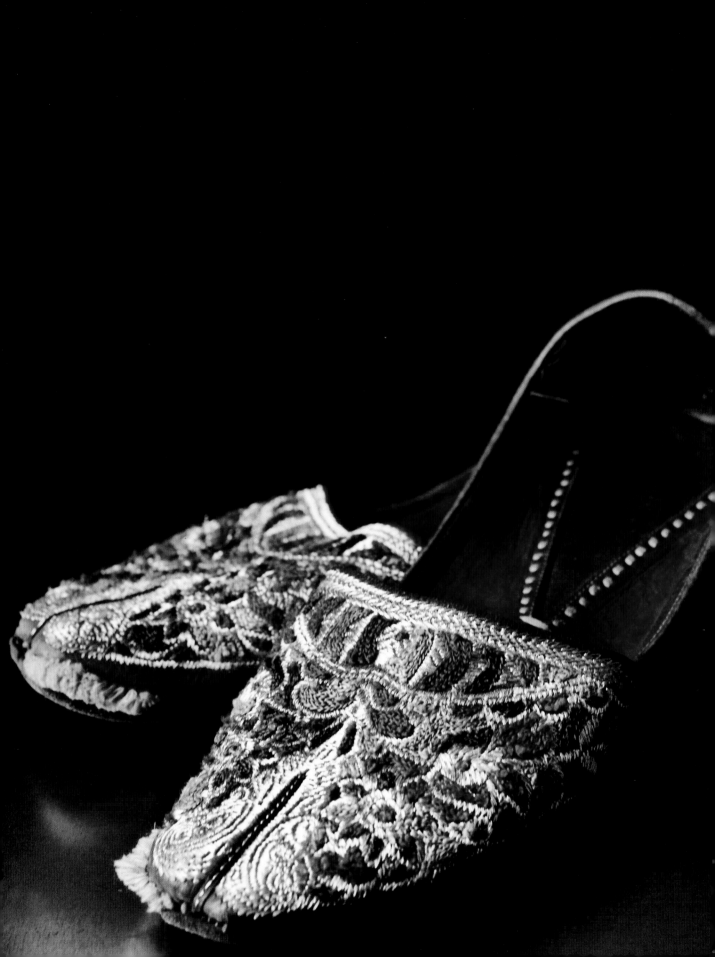

UMBER AHMAD

ENTREPRENEUR

The first memory I have of these shoes was when I was five or six years old. I noticed my mother wearing them, and she told me that they were from her mother, my grandmother. I always loved these shoes, because they were so beautiful. Mama's shoes were my dream shoes.

My mother married my father after knowing him for ten days. They then moved from Pakistan to Boston, and I believe it was around that time that my grandmother gifted the shoes to her daughter. She wanted my mom to have things to remember her by, and also of the country she was leaving behind.

The shoes are a Pakistani tradition, notably of the province of Sindh. These shoes are a gorgeous example of traditional Sindhi art, with the vibrant-colored threads hand-stitched into the leatherwork. Shoes aren't made this way anymore, with such care and precise attention.

My parents moved to the United States in 1968. My mother showed up in conservative Boston with her beautiful, brightly colored clothes and saris, which she would wear all about town. Part of the reason the shoes are so worn through is because she used to walk everywhere in them, even on the cobblestone streets.

I grew up in northern Michigan, and, when I was sixteen, I moved to Boston to attend university at MIT. It was then that my mother handed me those shoes. In northern Michigan, we were not surrounded by anyone of our culture, faith, or origin. I didn't grow up around other Pakistanis or have Pakistani friends; I didn't have people with whom I could identify culturally. It didn't faze me, because I knew in my heart all I needed to belong to was my family. That being said, I did assume that I was going to connect with other South Asians when I got to college.

I was surprised that that wasn't the case. I wasn't welcomed with open arms into the South Asian community. Instead, there were further distinctions and judgments made because I was born in the United States, and not in Pakistan or India. It wasn't enough

that my family came from that country, that all my relatives came from that country, that I spoke the language and wore the clothes. I was still considered different.

As a result, I didn't wear the shoes my mother gifted me right away. I continued to figure out how I was going to connect with my Pakistani identity. One day, I saw a flyer for a bhangra class. Bhangra is a traditional Punjabi dance. Despite being Punjabi, I didn't grow up dancing bhangra, so one day I convinced my sister, who was also at school in Boston, to sign up for a class.

We showed up at the first class wearing regular pants and shirts. The instructor told us we should wear our traditional Pakistani clothes the next time. So we did, and I wore these shoes.

My shoes gave me a confidence that it didn't matter if I belonged or not, because I knew that I belonged with the storied history of those shoes. I realized that what I was looking for in my life was already there. I didn't need to belong somewhere, because I already belonged to the one group that mattered the most: my family. I started doing bhangra seriously and became a member of a bhangra dance team, and I always wore those shoes.

Beyond dancing in them, I started wearing my shoes all the time. They became a topic of conversation, a way to connect with people. They were great with jeans or a long skirt or a pair of linen pants. They worked with everything, because they were so beautiful, and they stood out on their own. Most important, they were a part of me, my family and my history.

I think my mother wanted me to know that there were many paths I could walk, many places I could go. She believed very much in the idea of excellence and pursuing something well beyond the point of mediocrity. Amid all that drive, she always wanted me to be me.

There's something really incredible about literally walking in someone else's shoes. There's a sense of obligation and pride and opportunity. You think about that storied history when you slip them on your feet. When you stand in them, you are reminded that we stand on the shoulders of giants. My mother was a giant. Her mother was a giant. These shoes have been worn by three generations of women. Now they are so worn that I fear they will not hold up. But the story of these shoes? That will live on forever.

UMBER AHMAD By the time Umber Ahmad opened her first bakery in 2013, at age thirty-nine, she had already earned multiple degrees from MIT, the University of Michigan, and the University of Pennsylvania, finished successful stints at prestigious Wall Street firms, and started her own luxury brand consulting firm. One of her clients there, *Top Chef*'s Tom Colicchio, was so impressed by her baking skills that he backed her dream of opening a bakery, entitled Mah-Ze-Dahr, a translation from Urdu meaning "unexpected magic." After three years of online sales, Ahmad opened her first storefront in Lower Manhattan to rave reviews.

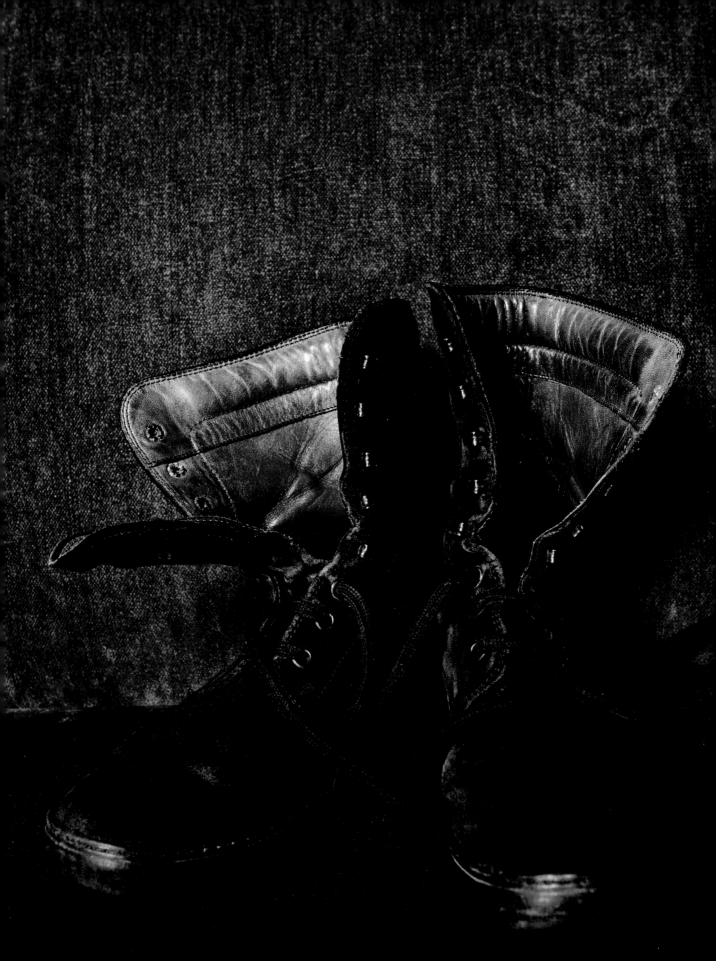

CHRISTIANE AMANPOUR

JOURNALIST & TELEVISION HOST

This pair of Tod's suede boots represent the game-changing moment in my career. They lace up in the front and have rubber soles and leather insides. They are my war boots; they're my field boots. They're the boots I walked in throughout my entire time as a foreign correspondent, and I still have them.

I bought them in the mid-1990s, when I was based in Paris for CNN. Through the frigid winter snows of the war in Bosnia to the broiling desert sands of the Iraq War, I had to have the right gear to be able to survive. These boots are agile, quick, flexible, durable, hard, and handsome! I could stomp in the snow and they were good in the desert sand. I wore them every day in the field. I was very practical about the way I dressed. I wanted to be hardy *and* look good, but never at the expense of practicality.

Nothing could have prepared me for what I met in Bosnia. I was then still a young correspondent. My previous story had been the first Gulf War, which was a "classic war," the kind where we witnessed armies facing off on a battlefield when we reported. Bosnia was all about the murder, ethnic cleansing, and genocide of ordinary civilians. It was a massive land-grab in the name of religion and ethnicity.

The Bosnian War was not just another story for me. It was a story that changed my life and shaped my career. And yes, I was wearing these boots on my journey of discovery and reportage, as the whole horrific genocide was unfolding in Europe for the first time since the end of World War II.

Bosnia was part of the Former Yugoslavia. As the country fell apart, Bosnia declared independence in 1992. It was a multiethnic state, and the Orthodox Christian Serbian population wanted to keep Yugoslavia whole. Failing that, they wanted to carve out a hunk of territory and attach themselves to Serbia itself. So they went to war against Bosnia's Muslims using the kind of genocidal tactics last employed in Europe by the Nazis. We witnessed concentration camps, we witnessed rape camps,

"THE BOSNIAN WAR WAS NOT JUST ANOTHER STORY FOR ME. IT WAS A STORY THAT CHANGED MY LIFE AND SHAPED MY CAREER. AND YES, I WAS WEARING THESE BOOTS ON MY JOURNEY OF DISCOVERY AND REPORTAGE."

we witnessed refugees being bused out and the siege and the shelling of towns. So nothing prepared me for watching women and children being shot through the head by snipers in the hills who deliberately targeted them.

The whole world had watched Jayne Torvill and Christopher Dean skating in the Sarajevo Olympics in 1984. And in 1992, I walked in these boots up to that same ice skating rink, which would be turned into a mass graveyard. These are the boots that I wore when I understood what our mission was in life, and that is to be a slave to the facts and never give in to opinion, ideology, or political agenda. The Serbs in the Bosnian War were telling lies about why they were conducting this genocide.

In these boots, I discovered what our mandate as journalists is. And that is to report the truth and to understand that objectivity does not mean neutrality. I had learned that objectivity was about giving each side a fair hearing. But you couldn't equate the Serbs and their inhumanity with the victims who found themselves guilty of nothing more than being Muslim in Europe. Your job is to bring back just the proof, the facts, the humanity of what is going on.

We were shot at by snipers and we had to dodge and run for cover. This was the first war in which journalists were deliberately targeted. These boots carried me through the war in which I had my total and utter professional and moral awakening.

CHRISTIANE AMANPOUR Christiane Amanpour is CNN's chief international anchor and the host of *Amanpour*, the network's award-winning global affairs program. She started her career as a reporter out of CNN's headquarters in Atlanta and then became a leading international correspondent, covering everything from the 1991 Gulf War to the bombing of the World Trade Center, the trial of Saddam Hussein, and the Bosnian conflict, a seminal time that she reflects on here.

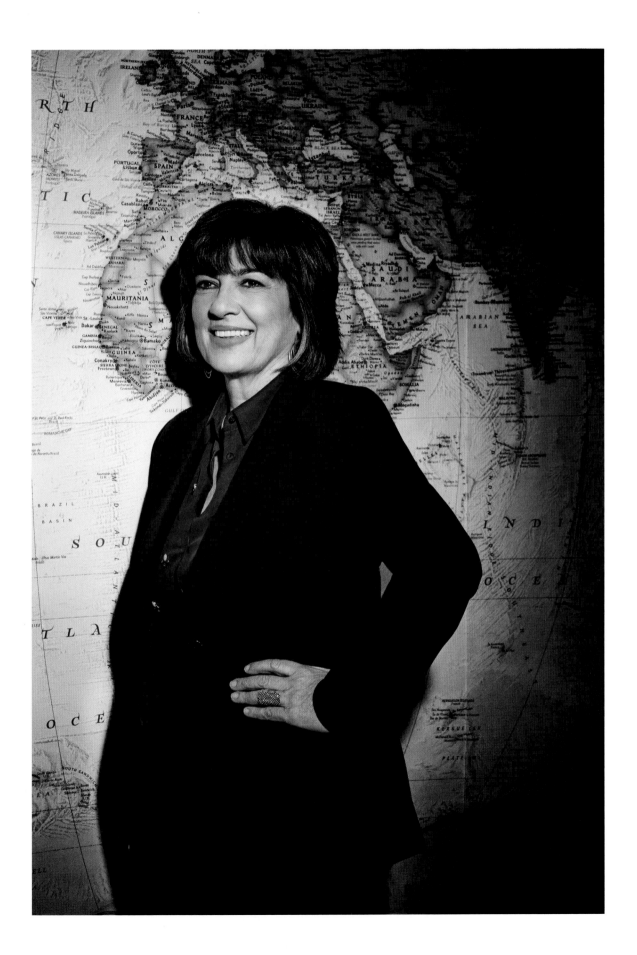

CHLOE
X HALLE
BAILEY

CONTEMPORARY R&B DUO

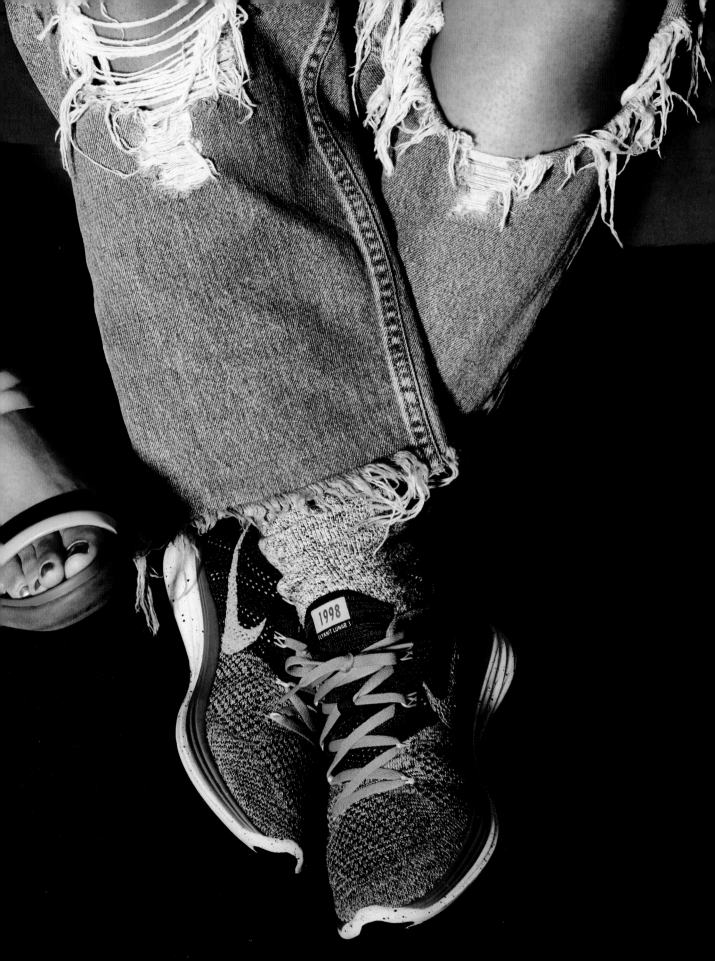

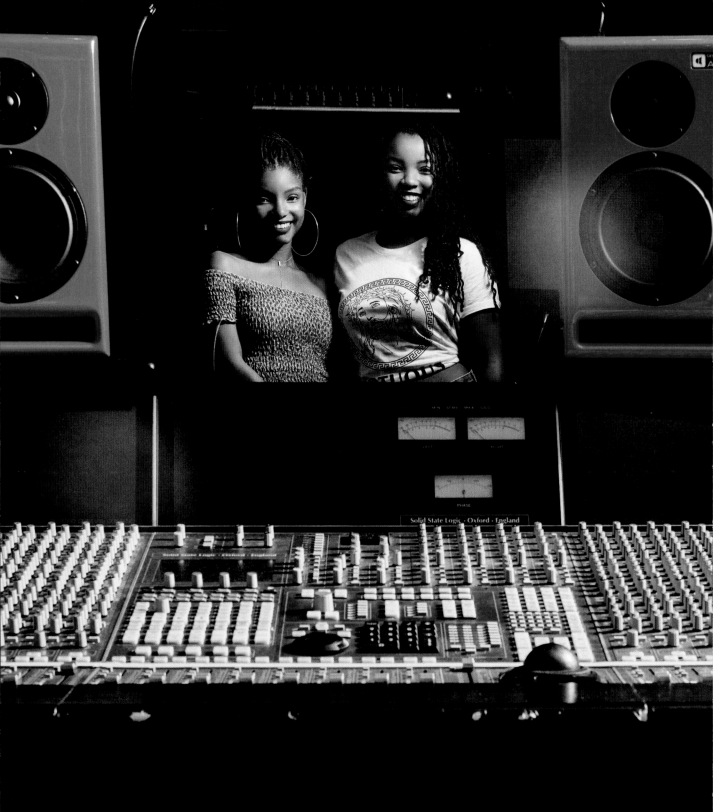

CHLOE

We first got to know Nike at a women's event back in Los Angeles when I was sixteen and Halle was fourteen. We had just signed with Beyoncé, but we hadn't announced it to the world.

Then Nike asked us to do a half marathon. We trained for about three months, and I remember being scared out of my mind. We would meet every two weeks with these other women who were entertainers—actors or singers—and we all trained together. After those three months, I realized that I could do the race, and it was pretty cool being able to overcome the obstacles that I had in my head and realize that I could do anything I put my mind to.

We went to San Francisco for the half marathon, and it was gloomy and really chilly, so we never got overheated. We ran with all these other women, which was a really encouraging energy, so I just wanted to keep going. It was fun. I was grateful to be a part of something where I could better myself, not only physically but also mentally.

It's the only half marathon I've done, but every time I go running, I use this shoe. I have so many other Nikes, but I always end up with these because they remind me of that time of my life. I got to customize my Nike Flyknit Lunars myself—I picked all the colors on the app, and they even have "1998" on them, for my birth year.

I truly believe that everyone has their own special gift and that we are all the same on the inside. Sometimes I'll get starstruck, but at the end of the day, I know that we're all human beings.

I feel that life is more fun when you're uncomfortable and when you feel nervous about something. That's when you know you're doing it right, because if you always feel safe, you don't really grow.

—AS TOLD TO AMANDA BENCHLEY

HALLE

The first video we made was "Drop." I was fifteen and Chloe was seventeen. We had spent the previous few years in the process of finding ourselves and experimenting with sounds and discovering what we wanted to sound like. I love jazz and those classic melodies that are so beautiful that they make your heart melt. So that was a staple, and those were the melodies that I wanted to make other people feel.

"Drop" had a mixture of jazz and hip-hop and a bit of my rap guitar mashed together. I remember that once we finished that song in our living room, we thought, this is it. This is what we want to sound like.

We knew we really wanted the video to be set in fields with horses and for it to feel free, because the song made us feel free. It was our vision, and we just chose what spoke to us. We love eclectic, beautiful, dreamy visuals, and our music goes very well with those angelic kinds of looks.

This amazing stylist named Armena picked out these cool shoes for me. They're multicolored with a sandal heel. They were so comfortable and stylish. I saw them and they took my breath away. I couldn't believe I got to wear them.

Right after we filmed the video, we performed at the White House for the 2016 Easter Egg Roll. Michelle Obama had invited us after seeing us at South by Southwest. One of our main goals was to get to the White House before the Obamas left. We were so excited!

Whenever I meet people like the Obamas, I always think, wow, that's really cool. But afterward, I have to try to forget about it and just internalize my gratefulness and remember that this world is so big, and none of the small things really matter. That way I can still be motivated and push myself to greater heights.

Singing at the White House was also right around my birthday. My mother knew how much I loved those shoes from the video, and she surprised me and gave them to me when we were all in Washington, D.C., together.

I have these shoes with me everywhere I go. Whenever I get dressed up to go to a nice event or if I want to feel cute and be comfortable at the same time, I'm always wearing them.

—*AS TOLD TO AMANDA BENCHLEY*

CHLOE X HALLE BAILEY Chloe and Halle Bailey are writers, singers, and producers as well as sisters. They were discovered on YouTube by Beyoncé, who then signed them on to her production company, Parkwood Entertainment. Their first EP came out in 2016, followed by *The Kids Are Alright* in 2018. They also contributed the title song for the TV series *Grown-ish* and later became regular cast members. Named as *People* magazine's "Ones to Watch," the duo accompanied Beyoncé and Jay-Z on their On the Run II tour in 2018.

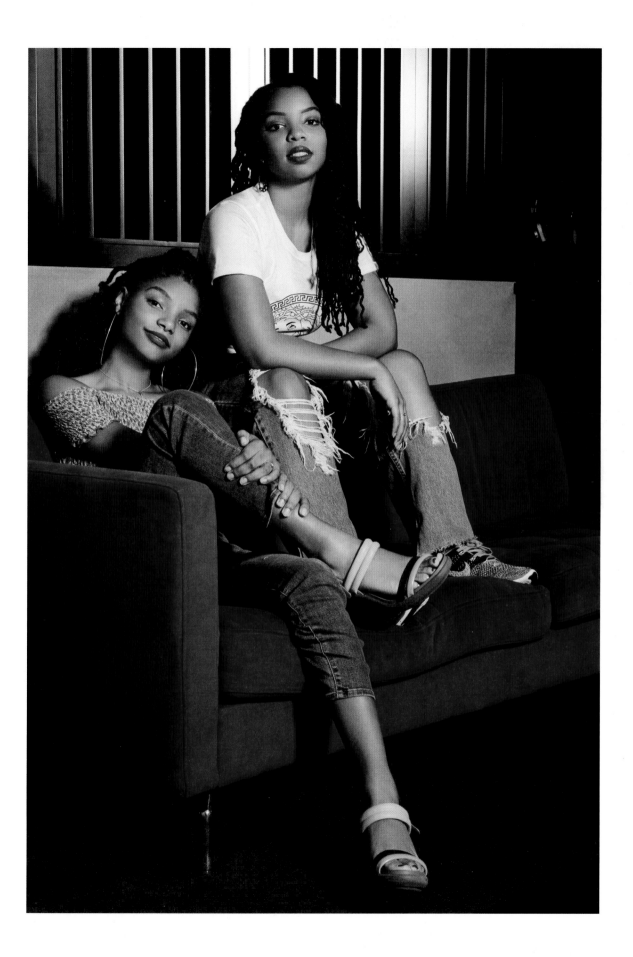

BOBBI BROWN

FOUNDER & FORMER CCO OF BOBBI BROWN COSMETICS

I am five feet tall. I never thought I was short until I came to New York City and started working with supermodels.

Suddenly, I was like, okay, so what, I'm short. When I was being photographed at an event, I would wear tall, fancy heels. One side of my closet was for my beautiful heels from Prada and Manolo Blahnik, and the other was for my sneakers and clogs. I have still to this day never found a pair of comfortable heels or even platforms.

I like to walk everywhere and I realized that I was changing shoes all the time, depending on the event. I would drop my kids off at school in New Jersey wearing a pair of sneakers, then throw on some pointy shoes to go to a corporate meeting or be on TV, then sneakers to work a fashion shoot, then high platforms for dinner with my husband or an event, and then be barefoot in the car on the way back to New Jersey. Those days were typical enough that I have an L.L. Bean bag labeled "New York," and that's where I would throw all my shoes for the day.

I founded Bobbi Brown Cosmetics in 1991 and sold it to Estée Lauder in 1995, staying on as chief creative officer. For twenty-six years, my life was very scheduled and overscheduled. I left the brand in October 2016. It was a personal decision, yet an

"BE WHO YOU ARE, WEAR JUST ENOUGH MAKEUP SO YOU FEEL GOOD, AND TAKE CARE OF YOURSELF. BE HAPPY, HAVE FUN, AND DRINK TEQUILA."

important one. It was time to do something else. I was ready to be an entrepreneur and my own boss again.

When I left the brand, I realized that I was able to just wake up in the morning, put my hair in a ponytail, throw on a pair of jeans, and my Adidas sneakers, and go to lunches or meetings. I realized the more I'm able to be myself, the happier I am. I don't need to walk into a room wearing pointy heels.

When I was on my last book tour, I did not put on a single pair of heels. I traveled extensively and wore my Adidas sneakers the entire time. I sat on TV sets wearing sneakers and it felt great.

I have about six pairs of different Adidas sneakers, which I usually wear with either leggings or pencil jeans. I've gotten varied reactions, from "Oh my god, you look so comfortable, I wish I could dress like that," to President Obama, who said: "Nice kicks."

I started my company with a simple philosophy that you should be who you are, wear just enough makeup so you feel good, and take care of yourself. Be happy, have fun, and drink tequila. That's my aesthetic and just who I am.

BOBBI BROWN Bobbi Brown is a beauty-industry titan, world-renowned makeup artist, bestselling author, and serial entrepreneur. As a professional makeup artist, Bobbi created ten simple lipsticks that evolved into a global beauty empire. She has also written nine beauty and wellness books. Her latest endeavor is EVOLUTION_18, a line of lifestyle-inspired wellness products that launched in the spring of 2018.

CHRISTY TURLINGTON BURNS

MODEL & FOUNDER OF EVERY MOTHER COUNTS

I ran my first marathon, in New York City, in 2011. I had just launched a nonprofit called Every Mother Counts to improve access to essential maternity care around the world. But I wasn't really a runner, and I needed a pair of shoes. My friend who was a seasoned runner wore Brooks, so I figured he knew a thing or two.

I ran playing sports as a child, and I ran off and on for exercise as I got older, but I probably hadn't run much more than five miles at a time. After we started the Every Mother Counts campaign, we were offered ten spots for the New York City marathon.

I have lived in New York City for more than thirty years, so I felt that I had to take one of the spots, since I was the founder. I reached out to friends and put together a team and started training in late July. We had just three months, which wasn't a ton of time, so I literally started running the next day. It took me until I completed my first ten miles before I would say out loud that I was running the marathon.

In the first week of training, I made the connection between the work of Every Mother Counts and running long distances, because distance is one of the biggest barriers that prevents women from accessing health care of any kind. Millions of women have to walk miles to reach a provider or a clinic, let alone a hospital, and oftentimes when they get there, it's too late. This resonated with others on my team and all the people who supported us throughout the training and race. In the end, it's not just you by yourself having a baby; you need support from your partner, your family,

providers, your community. You need a support system to help you through safely. I think that's exactly what you need when you run a long-distance race too.

Every day I ran I would recite, "I think I can, I think I can," and then that changed to "I know I can, I know I can." I felt like a badass. It was amazing that we were running this race not only for ourselves, but also to educate others. For that first marathon, I remember struggling a bit toward the top of First Avenue. It's a long and gradual climb into Harlem, and the crowds lighten a bit. I hit what I now know is "the wall" around mile twenty or twenty-one. I was afraid that if I stopped running and started walking, I wouldn't be able to start running again. I said that aloud to my friend Nick, whom I was running with. He said, "It's fine. There's no shame in walking. Walk. We'll walk and we'll pick a spot ahead and when we get there, we will start running." I talked myself back into running by thinking of the women in Tanzania that I have met who have had to walk just as far as a marathon (26.2 miles) and farther to reach the care they need, sometimes without any shoes at all. I started running again and didn't stop. When I crossed the finish line I was filled with endorphins and such a sense of accomplishment and euphoria, just like after I had given birth.

I never expected that I would continue running or love it so much. Once you have run hundreds of miles in a pair of shoes, it's hard to throw them away. I have every pair I have trained and raced in on a shelf. I've been thinking about writing the race and date on the heels of each with a Sharpie, so I can remember all the time and effort that went into them. I haven't been able to throw any of them away. Marathon medals are great, but it's my shoes that are the real badges of these accomplishments

—*AS TOLD TO AMANDA BENCHLEY*

CHRISTY TURLINGTON BURNS Christy Turlington Burns is a mother, global maternal health advocate, and founder and CEO of Every Mother Counts. After experiencing a childbirth-related complication following the delivery of her first child in 2003, Christy was compelled to direct and produce the documentary feature film *No Woman, No Cry*, to explore challenges and solutions that impact maternal and infant health around the world. In 2010, she founded Every Mother Counts to heighten awareness about the global maternal health crisis. Every Mother Counts invests in programs around the world to ensure all women have access to quality maternal health care. Christy has been recognized as one of *Time*'s 100 Most Influential People (2014) and one of *Glamour* magazine's Women of the Year (2013). In March 2016, EMC was recognized as one of *Fast Company* magazine's Top 10 Most Innovative Companies in Not-for-Profit.

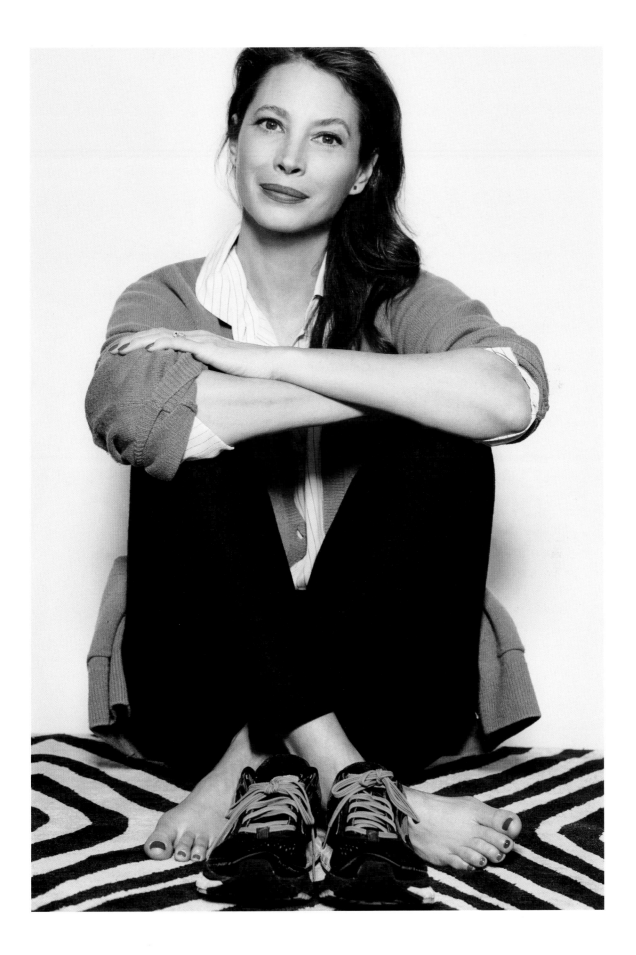

BARBARA BUSH

FIRST LADY OF THE UNITED STATES OF AMERICA

All my life, every summer, I wore Keds. During the school year, I wore moccasins, but in the summer we wore Keds to play tennis. Then, when we were in the White House, I was noticing that everyone was wearing big, clunky athletic shoes, and I said to George, "You know, you can't find Keds anymore." So he called the president of Keds and then, for my birthday, he brought in a bag of thirty different-colored pairs of Keds, every color you've ever heard of, mostly pastels. I was thrilled, I thought it was the funniest thing.

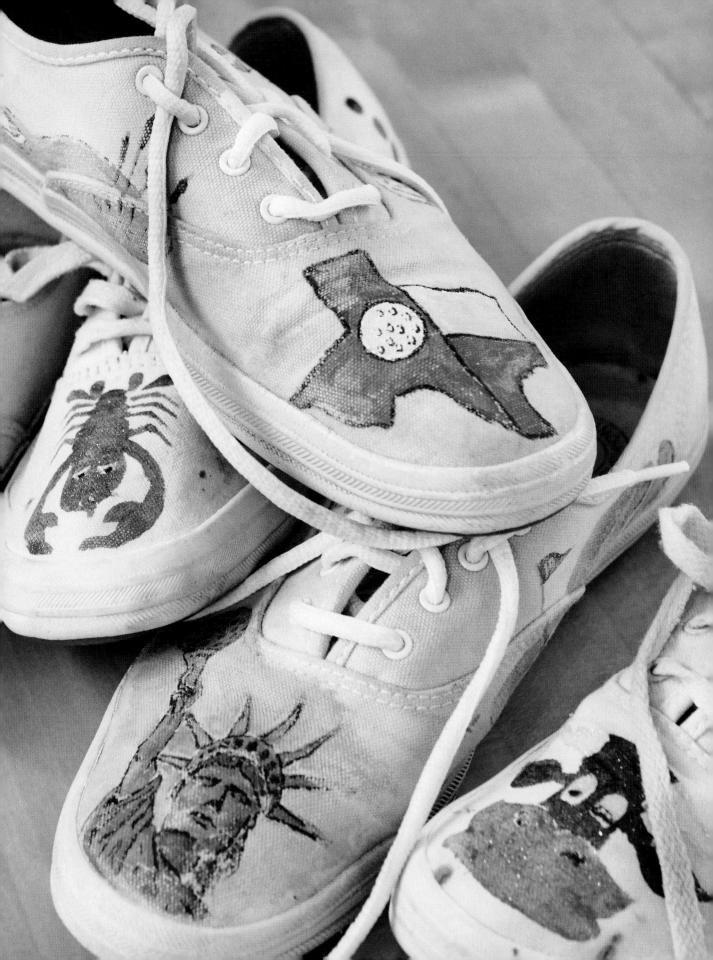

"AND I THOUGHT, I SHOULD HAVE SAID, 'YOU KNOW, YOU CAN'T BUY DIAMONDS ANYMORE?'"

I divided the Keds into three piles, but with the right and left shoes in different colors. I had three bags for them—one for Camp David, one for Kennebunkport, and one for the White House. I never wore the same color together. I would walk into some place, and you'd see kids looking at me and saying to their mom, "Look, she doesn't know she's wearing two different-color shoes." It was fun because you could see people looking at you quizzically and thinking, wow.

Then people started sending me Keds. You won't believe what people will do when you are First Lady. They would call the office and get my size and send them. I went to the dedication of a garden in Kennebunkport that they named for me, and someone brought me another bag of Keds, which I ended up giving away to the homeless because I already had so many.

People starting painting Keds with designs and sending them to me too, pairs with a lobster or a flag of Texas or golf clubs or glitter fish. And I would mix and match them.

My husband was so thrilled to give me the Keds that day. He is a funny man. And I thought, I should have said, "You know, you can't buy diamonds anymore?"

—*AS TOLD TO AMANDA BENCHLEY*

BARBARA BUSH Former First Lady Barbara Bush was the wife of President George H. W. Bush and the mother of President George W. Bush. A fierce advocate for literacy, she founded the Barbara Bush Foundation for Family Literacy and wrote three books: *Millie's Book: As Dictated to Barbara Bush*, whose profits were dedicated to literacy causes; *C. Fred's Story: A Dog's Life*; and *Reflections: Life After the White House*. She died on April 17, 2018, just months after her *Our Shoes, Our Selves* interview.

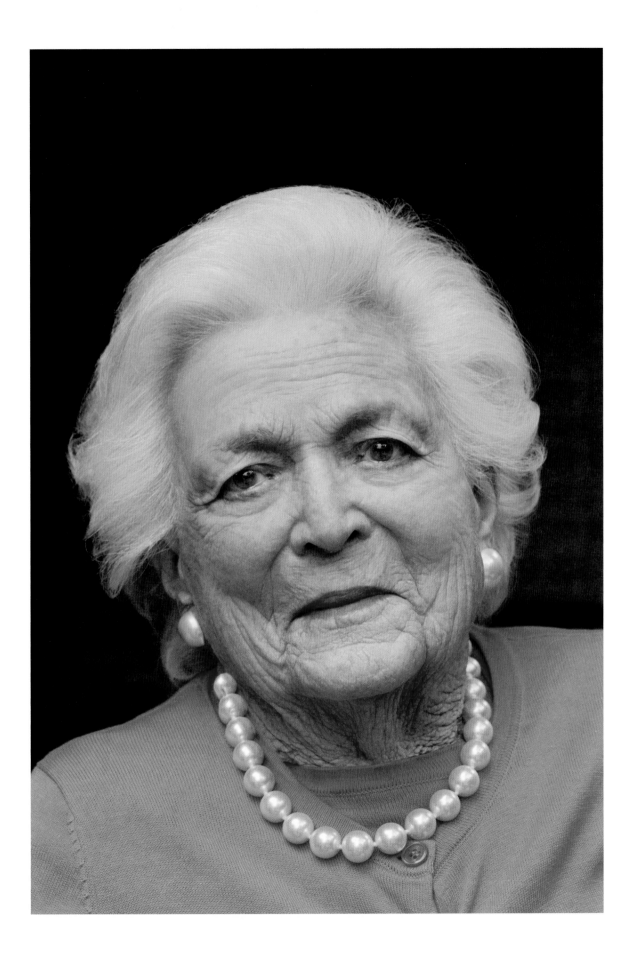

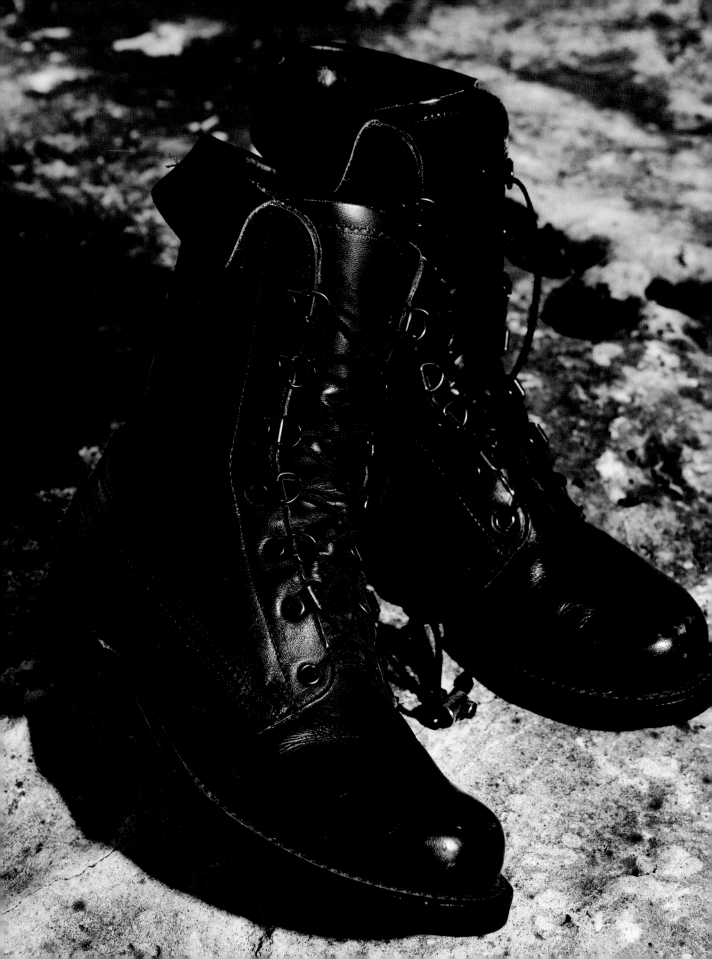

EILEEN COLLINS

RETIRED ASTRONAUT & AIR FORCE PILOT

When I was nineteen, between my sophomore and junior years in college, I joined the United States Air Force Reserve Officer Training Corps (ROTC). I was issued my first pair of combat boots in basic training at boot camp in Ohio.

I joined the military because I love airplanes. As a child, I started reading about airplanes and got interested in military flying. I would read stories about World War I, World War II, the Korean War. I was fascinated by the development of the fastest and most capable aircraft in the world. I grew up in Elmira, New York, the location of the National Soaring Museum. Elmira was the soaring capital of the world back then—now it's just the soaring capital of America. I went to summer camp there from ages seven through twelve. I would watch the gliders fly off Harris Hill and always thought it would be cool to be in one. On weekends, my dad would take us up to watch the tow planes haul the gliders out. They would tow the planes to a high altitude, release, and soar overhead as long as the sun was up. My family did not have the money to pay for flying lessons. If I was going to learn how to fly, I had to do it in the military.

When I first put the boots on in basic training, I thought, *What am I getting myself into?* They were a bit clunky because they're heavy, and hard to march in. But I always knew I wanted to be in the Air Force, and I knew I wanted to stay. I was not going to quit. We stayed in an old barracks building. The beds were tiny little cots, and it was cold. Every morning and afternoon we would put on our boots and fatigues and do our marching lessons. In the mid-1970s, it was new for men and women to march together.

I enjoyed marching. It was almost like dancing, because you have to learn how to do everything together, as a unit, and not be out of step. We would march and officers would call commands, and we got really good by the end of six weeks.

I wore the combat boots through survival training, water survival training, and flight training. Not the exact same pair, because I would wear them out. It was amazing that we ever wore them out, but in survival training you'd be in the mud or the forest and the boots would get wet and eventually be useless. I have probably had twelve to fifteen different pairs throughout my career. I was never a great fashion person. I know a lot of people like their clothes to express who they are, and I think that's great. But when you're in the military, everyone wears the same thing. The goal is to stop thinking about things that aren't directly related to the mission. You want to be focused, and we're all working together, as a team.

That ROTC six-week summer program was a great experience and a huge confidence booster. I learned things like how to fight and how to protect myself. I sat in my first airplane: an A-7. I thought, *Oh my gosh, I love this. This is what I want to do.* That summer of 1976 was when the Air Force, under pressure from Congress, allowed women to fly Air Force aircraft. That made it real, not some show.

After I graduated from college in 1978, I started pilot training at a base in Oklahoma. The space shuttle program had just picked its first women astronauts. There were thirty-five astronauts in the first space shuttle class, including Sally Ride, and they came to my base for parachute training. It was all over the national news. I thought: *That's what I am going to do!*

The women were engineers and scientists. They were role models to me. In 1990, NASA hired the first woman pilot to fly its rockets. This was such a huge honor for me and allowed me to continue my flying career and go farther, faster, and higher than ever before—in the same type of boots I had worn years earlier in basic training.

—*AS TOLD TO AMANDA BENCHLEY*

EILEEN COLLINS In 1999, Eileen Collins became the first woman to command and pilot a space shuttle. Before being selected for the first female class for NASA, she was an Air Force colonel and former instructor pilot who logged over 6,751 hours in thirty different types of aircraft. The recipient of NASA's Outstanding Leadership Medal, she has also logged more than 972 hours in space. She retired from NASA in May 2006.

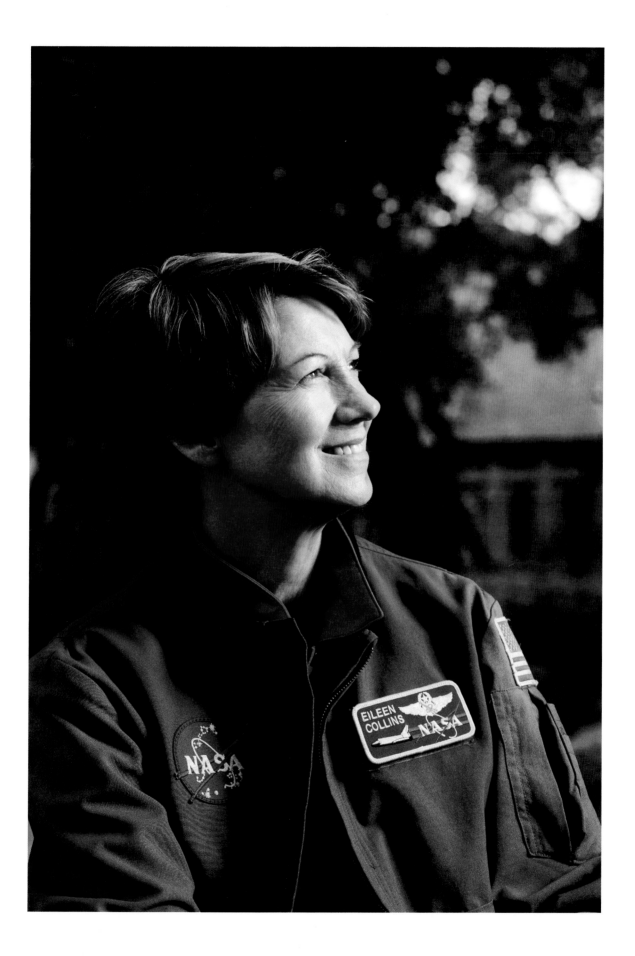

SENATOR SUSAN COLLINS

UNITED STATES SENATOR, MAINE

When I was elected to the Senate, I felt it was very important to try to be present for every vote. Margaret Chase Smith, who was a senator from Maine, was a tremendous role model for me growing up. In 1971, when I was eighteen years old, I was chosen as part of the Senate Youth Program, and I remember looking up to her, so proud that she was my senator. She also made me think that women could do anything: One of her signature accomplishments was that she did not miss a vote for thirteen years.

So then, in 2008, I was involved in a very contentious reelection campaign. One of the issues that I was touting to my constituents was that I had never missed a vote on the Senate floor. One day, I was in a meeting of the Homeland Security and Governmental Affairs Committee. At that point, I was the ranking Republican and my dear friend Joe Lieberman was the chairman. We were almost finished with our meeting when a roll call vote was called on the Senate floor. And we know when that happens because a bell rings and also a particular light on the clock shines.

I got a note from my staff saying that a vote had been called and the light was on. Sure enough, the white light was on, which means that you have fifteen minutes to get to the floor. There's a little grace period of an additional five minutes. Chairman

Lieberman had a member of his staff call over, and they assured us that the vote would be held open so we could finish our work in committee. But I saw the time ticking down and started getting very nervous that I would miss the vote.

We had to keep working and it got down to about two minutes left in the vote. And I leaned over and whispered to Joe, "I just don't trust that they're going to hold the vote open." And he said, "Go, go." So I ran down to get onto the subway over to the Capitol and twisted my ankle. I was wearing quite high heels, higher than what I would usually wear. I had bought them at the Brooks Brothers outlet in Freeport, Maine. My ankle was killing me, but I jumped onto the subway, ran up the escalator, got into the elevator—and the cloakroom staff is holding open the doors and saying, "Run, run. The gavel is about to come down and that will end the vote." They were almost finished voting.

And the presiding officer said, "Is there anyone in the chamber who wishes to vote or change his vote?" And I raced in and said "Aye" just as the gavel was coming down. That was the closest that I have ever come to missing a vote.

And I've still never missed one since I was first sworn in in 1997. That's more than sixty-five hundred roll call votes. That day was as close as I've come. But the problem was that I didn't realize that I hadn't sprained my ankle, I had broken it.

I cannot wear those heels anymore, but I won't get rid of them. For some reason, they symbolize my commitment to always being there for the state of Maine, and not letting adversity stop me. I think it's my Maine work ethic. But I do believe that women senators work really hard. We don't agree on the issues, but there's an extra burden placed on women to show that we can do the job. We won't be held back or let obstacles like broken ankles deter us from reaching our goal.

—AS TOLD TO AMANDA BENCHLEY

SENATOR SUSAN COLLINS Senator Susan Collins is the four-term senior senator from Maine. First elected in 1996, she has successfully introduced bills such as the College Affordability and Access Act and the Teacher Tax Relief Act, helped repeal tax breaks for the tobacco industry, and served as the chairwoman of the Senate Homeland Security and Governmental Affairs Committee. Senator Collins is also the coauthor of the Collins-Lieberman Intelligence Reform and Terrorism Prevention Act and has been a strong advocate for health issues such as Alzheimer's disease and diabetes. Known as Maine's Marathon Lady, Senator Collins has cast more than sixty-six hundred consecutive votes. In 2015, she was ranked the nation's most bipartisan senator.

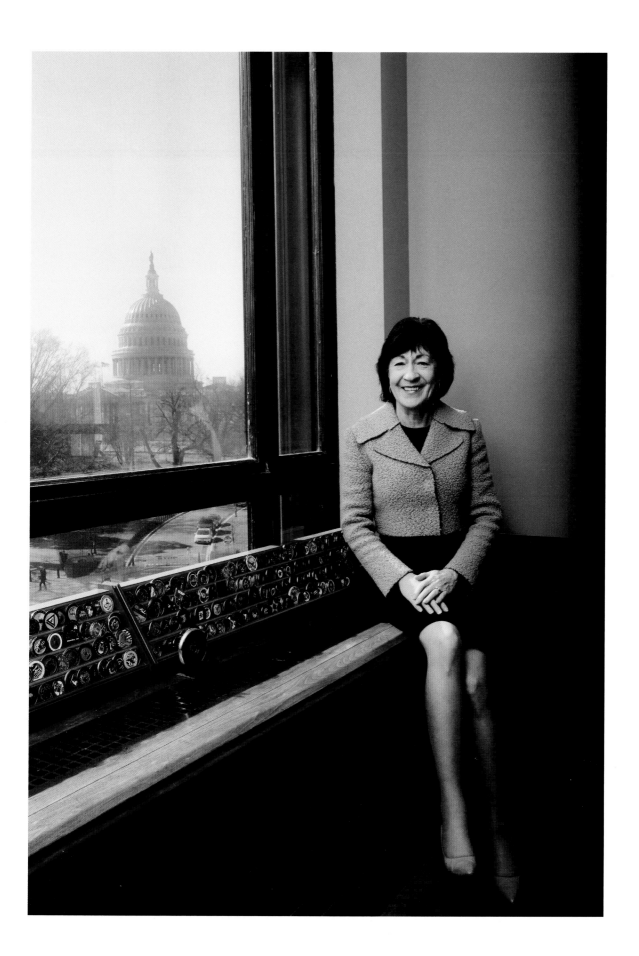

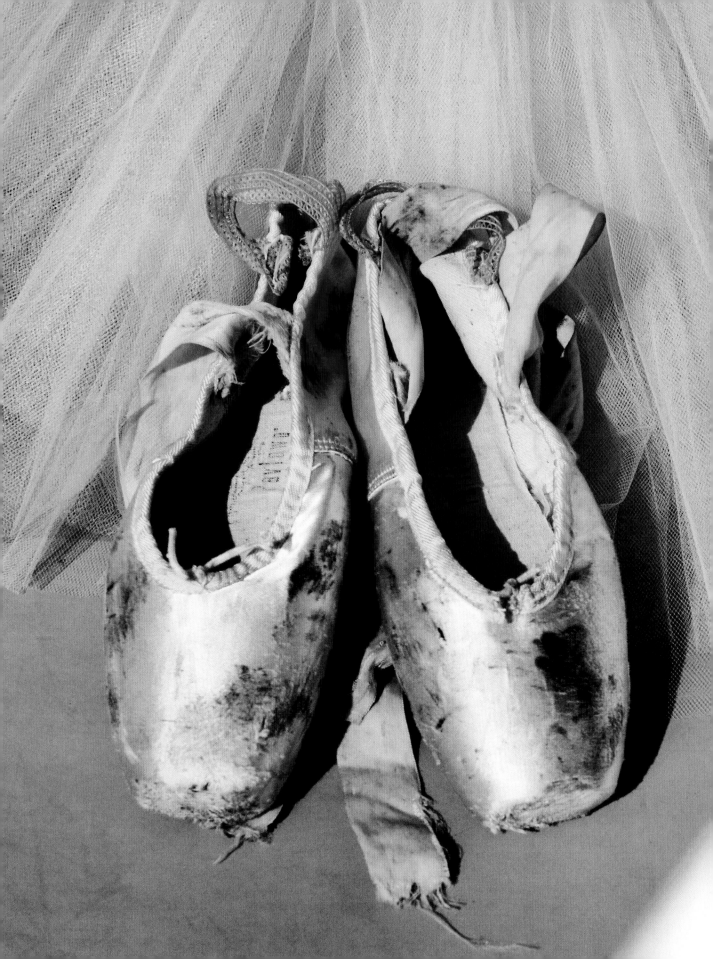

MISTY COPELAND

BALLET DANCER, AMERICAN BALLET THEATRE

I was thirteen when I started ballet. I was always moving and creating to music, and it wasn't sparked by anything I'd really seen before. It was just something I imagined in my head. When I was twelve, I decided to audition for my middle school drill team, even though I had no real dance experience other than what I did in my bedroom.

I auditioned for the position of captain and I got it. It was kind of a big shock to my family because I was such an introvert at home. The fact that I even wanted to go for something like this was shocking to everyone because I just didn't want to be seen.

I didn't know what it was about dancing, but it was very comforting for me to be onstage. I felt safe, like no one could touch me. My drill team coach immediately noticed my body proportions, which she said were ideal for ballet. She had a friend who owned the local ballet school in San Pedro, California, where I grew up, and who was offering free ballet classes at the local Boys and Girls Club.

I was already so invested in the drill team, and I had no motivation to integrate ballet into my life. I had finally found something that was my own, that I didn't have to share with my five siblings. But despite my feelings, Cindy Bradley, the ballet teacher, was adamantly sending letters to our home for me to give to my mom, week after week. I never gave them to her.

Eventually, Cindy got me to take the class. I was in my P.E. clothes: gym shorts, socks, and a T-shirt. I took a couple of classes and Cindy immediately expressed, "I've never seen a talent like yours. Will you please come to my school on full scholarship?"

I didn't think that ballet was something I would continue to do. It wasn't until I had the attire—my leotard, tights, and ballet slippers—and I was in a proper ballet studio, with mirrors, that I could see my reflection. That's when I fell in love with ballet. I felt really empowered and beautiful for the first time in my life.

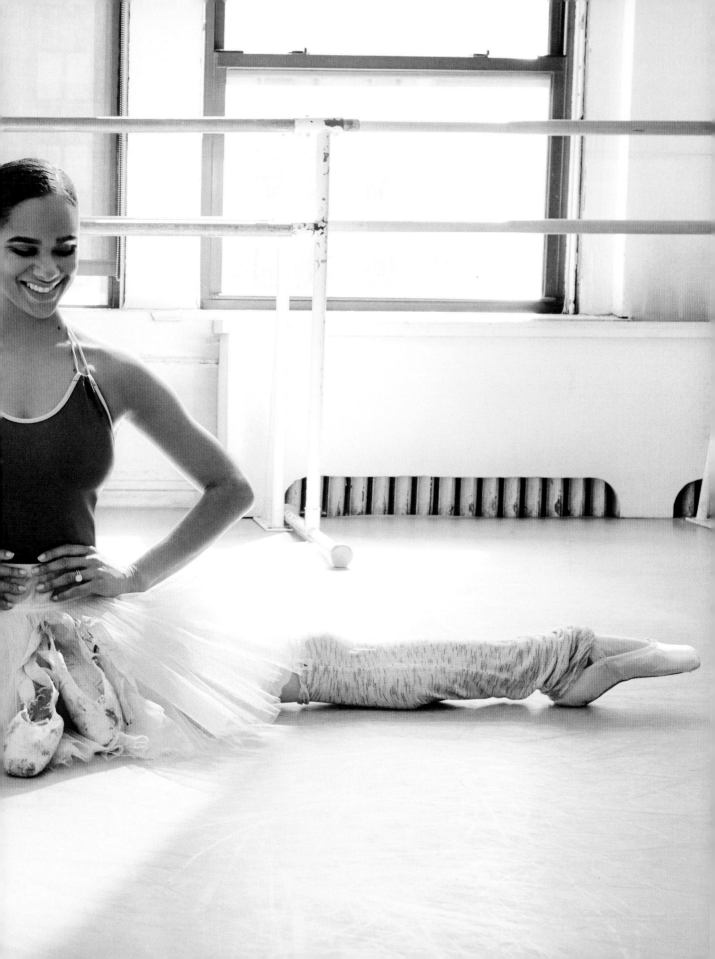

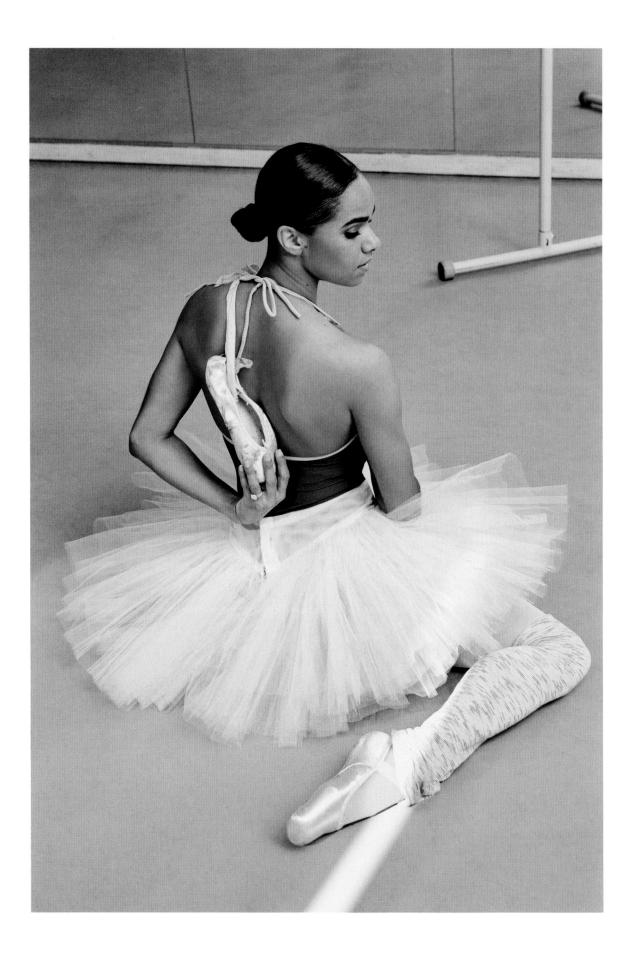

"POINTE SHOES SEPARATE YOU...THEY MAKE YOU A BALLERINA."

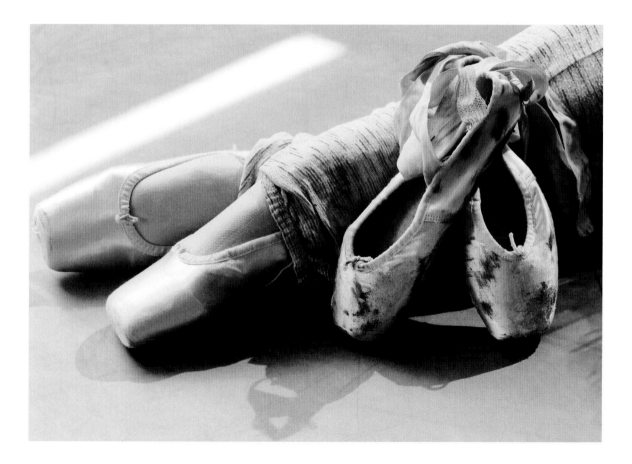

After two or three months, my teacher wanted to put me in pointe shoes. It normally takes seven years of strict training in ballet class every day before you are given the opportunity to dance en pointe. This is so you have the proper structural alignment and muscle strength to support yourself. It can be really dangerous, but my teacher thought I was ready.

My mom was struggling at the time, working several jobs. My siblings and I were living in a motel. My mom had a lot on her plate. She thought that I'd had my time with ballet, and that we couldn't do this anymore; it was too much strain on our family. My teacher heard that and told me, "I'll give you pointe shoes if you stay," and she came with me to get fitted.

They selected a pair of Capezio shoes called the Pavlova. They were bubblegum pink. It was so odd that they were that color, because everyone else's shoes were what was called European pink. The store made sure they were my size and showed me how to break them in and sew ribbons and elastics on them.

The shoes were so narrow and I have really big feet, for which I was teased a lot when I was a child. Yet when I entered the ballet world it was like, "Oh my God, it's so beautiful that you have these long, narrow feet that make you look even taller and longer." That was the first time these attributes of mine that were considered clownish in the real world were now considered beautiful.

It was extremely painful that first time I went up en pointe, but I knew that it was something that I had to do to be a ballerina. I was really, really strong-willed as a child and never gave up on things. There wasn't a question of "This hurts, I'm not going to do it." I knew that I just I wanted to be better, I wanted to get to a point where it didn't hurt and it was easy for me.

That first pair of bubblegum-pink Capezios changed my life. I wore those shoes for more than a month. Now I go through ten pairs of pointe shoes a week. Pointe shoes separate you from being just another ballet dancer—they make you a ballerina.

—AS TOLD TO AMANDA BENCHLEY

MISTY COPELAND Misty Copeland is a principal dancer for the American Ballet Theatre, the first African-American to hold that title. She first joined the company in 1999, at the age of nineteen, four short years after her first dance class. Copeland was a member of President Obama's Council on Fitness, Sports, and Nutrition and is the author of two books: the bestselling memoir *Life in Motion: An Unlikely Balance* and the award-winning children's book *Firebird*.

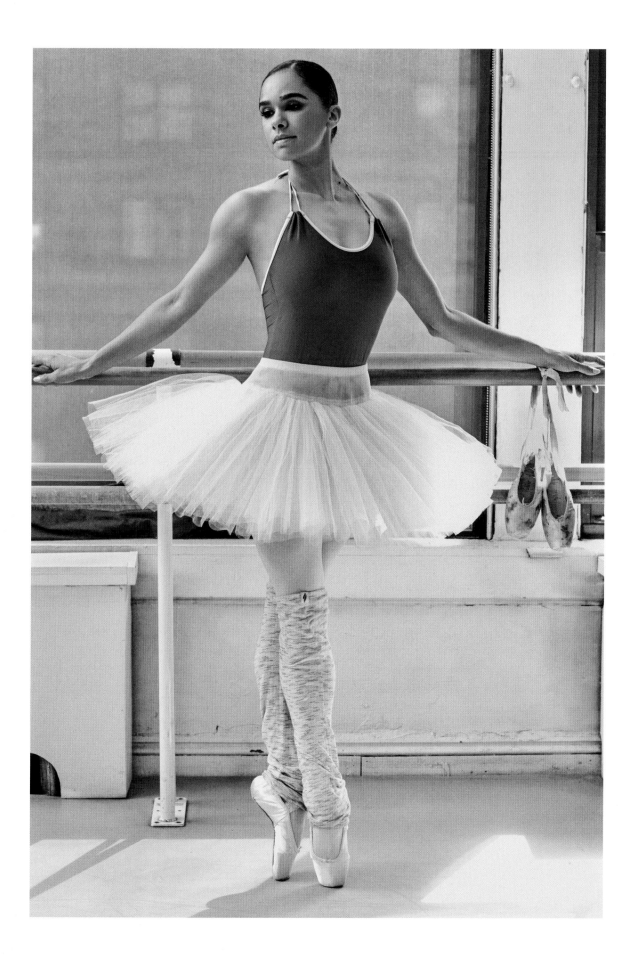

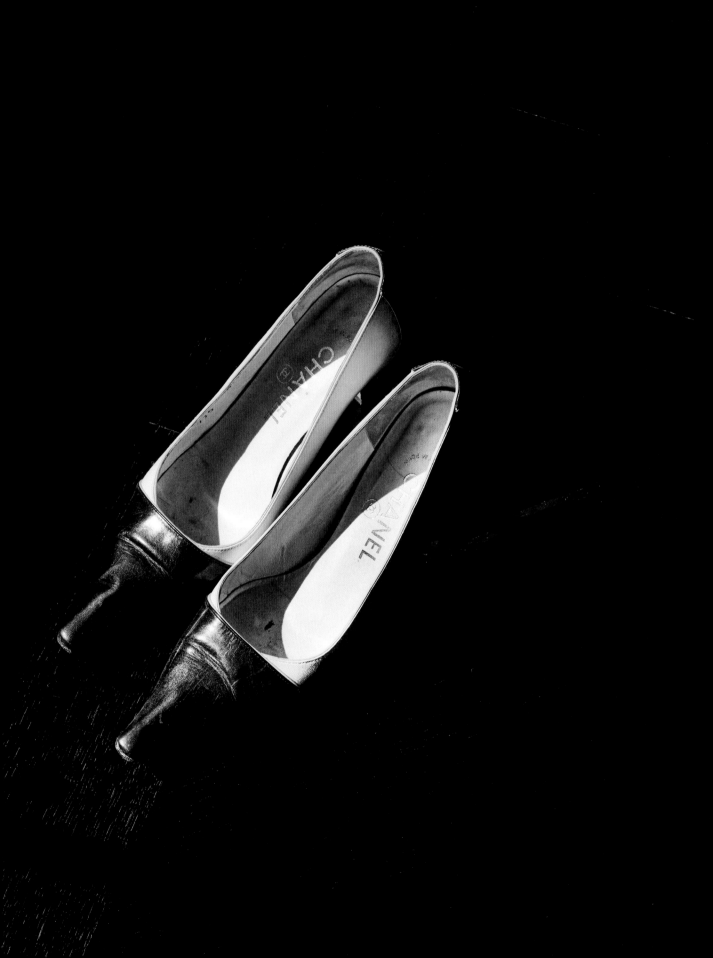

KATIE COURIC

JOURNALIST & AUTHOR

I grew up in a very middle-class home, raised by parents who emphasized the importance of getting into and graduating from a good college. My dad was an elegant Southern gentleman, incredibly well read and cultured, but not a snob. My mom was from Omaha, Nebraska, a no-nonsense Midwesterner, and although she wasn't a "career woman," she channeled all her ambition into her children. Though my dad never made a ton of money, I had a wonderfully happy childhood, and we grew up in a great neighborhood with a real sense of community. We didn't belong to a country club or go on fancy vacations, but I have such vivid memories of playing red light, green light, baseball in the street and riding our banana bikes all over Arlington, Virginia.

When I unexpectedly became coanchor on the *Today* show in 1991 and started to become successful in television, there was a bit of cognitive dissonance for me in terms of the way I was raised.

Suddenly I had enough disposable income to buy expensive items I never would have dreamed of purchasing when I was younger. My mom was frugal—even well into her eighties, she would find the Progresso soups that were on sale and the best deal on cottage cheese. If I got a five-dollar bill from my Nana for my birthday, it went right into my college fund. I never wanted for anything; I was just very conscious of spending money and what things cost. It was quite an adjustment for me to say: "You can afford that. It's okay to buy it."

I always tried to wear outfits on the *Today* show that I thought people watching could afford. I envisioned the typical viewer as a young associate at a law firm, and I didn't want there to be a big disconnect between what I was wearing and what was within her budget. So I would wear clothes from J.Crew and the Gap and affordable shoes from 9 West. After a few years, I graduated to Stuart Weitzman.

Slowly, people started seeing that my feet were getting a lot of exposure on television, and companies started to send me shoes or give me a discount. Very exciting! I love shoes and I'm frugal. It was a match made in heaven.

I think at some point, I decided to get in touch with my inner Carrie Bradshaw and embrace my success. I headed to Saks to buy a pair of Chanel shoes. Chanel!

In addition to standing for "copious cash flow," those double Cs announce to the world, "I've got some serious disposable income." But I didn't stop at the shoes. I also bought a Chanel suit to go with them!

I wore the whole getup to a luncheon in New York City for Queen Rania of Jordan, and I didn't know whether I felt like a lady who lunches or a successful career woman—or maybe a little of both. But it was a great feeling to be able to buy this extravagant outfit myself, because I'm a big proponent of financial independence. You never know what's going to happen in your life.

In fact, the unexpected did happen. After a nine-month battle, my incredible husband, Jay, died of cancer when he was just forty-two. Maybe that's why a few years later I thought: *What are you waiting for? You want to buy something beautiful. Go ahead and do it now!*

I still feel most comfortable in clothes that don't require a second mortgage. And when I see the price tags on some designer shoes, I still break out in a cold sweat.

Don't get me wrong: I love beautiful things, but in the grand scheme of things, they just don't matter that much to me. I mean, I've never been particularly materialistic, but since losing people I love, I always remember that inanimate objects are "just things." What I truly value are relationships. My family and my friends. But that doesn't mean I don't have a little more of a kick in my step when I'm wearing a great pair of shoes.

I did wear the Chanel shoes on the *Today* show a couple of times. I felt a little funny in them, like I was showing off. Every time I clean my closet and think about getting rid of them, I can't bring myself to do it. They symbolize something to me—that I made it. But I don't need to buy another pair to remind me.

—AS TOLD TO AMANDA BENCHLEY

KATIE COURIC Katie Couric is an award-winning journalist and bestselling author. She is the executive producer of the documentaries *Fed Up*, *Under the Gun*, and *Gender Revolution* as well as the "America Inside Out" docu-series. In 2006, after a fifteen-year run as coanchor of NBC's *Today Show*, Katie became the first woman at the helm of an evening newscast as the solo anchor of *CBS Evening News*. She has won numerous awards, including an Alfred I. duPont-Columbia University Award, a Peabody Award, an Edward R. Murrow Award, the Walter Cronkite Award for Excellence in Journalism, and multiple Emmy Awards.

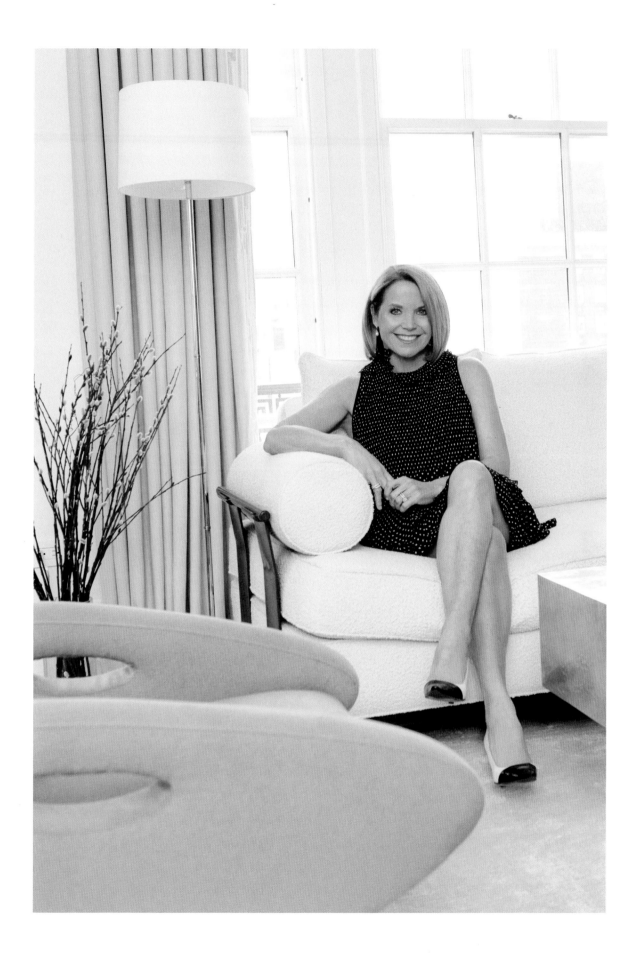

STACEY CUNNINGHAM

PRESIDENT, NYSE GROUP

When I was nineteen, I was studying engineering in college and got an opportunity to intern on the New York Stock Exchange trading floor. It was 1994, the year AOL opened its gateway to average Americans to surf a new thing called the internet. I entered the front door of the NYSE unsure of what I'd find but confident, at least, in my attire: a suit and a pair of heels that I handpicked for my first day on the job.

The minute I walked on the trading floor, I felt the intense energy of thousands of brokers and dealers shouting out orders and discarding paper tickets. It was mayhem to the outside observer, but a time-honored, disciplined process to those in the know.

A mere fifteen minutes into my internship, I had found a home for my career. While I stood in my heels for ten hours on the trading floor that day, I realized my shoes were my center of my gravity. Their importance rested on their ability to ground and energize me rather than impress my peers. Heels weren't going to work.

After college, I returned to work full-time on the trading floor as a specialist. The dot-com boom was in its early days, and the ferocity of trading was palpable. In 2000, I marked a major milestone, becoming an official member of the Exchange. Membership meant I now had a "seat" for trading, but it didn't mean I actually "sat," not even for lunch.

Specialists like me were responsible for trading a "panel" of company stocks each day. With millions of dollars changing hands in seconds, you focus on what matters most: managing your clients' stocks. By this stage, I had ditched the heels for more sensible Rockports.

Those Rockports came to symbolize much more than comfort for my feet. They carried me through the tragic events on 9/11. Only blocks from where the Twin

Towers stood, all NYSE employees, including me, were thrust into the chaos as we escaped from lower Manhattan. I didn't plan on a long walk that day, but I made it home, covered in dust. Those shoes remained on my doorstep for three weeks as a reminder of what so many of us had endured.

We returned to work six days later, and I eventually decided I needed new shoes. The only other female specialist at my firm at the time was a devotee of Dansko clogs. Unlike a lot of women back then who wore sneakers to commute and heels in the office, we did the reverse. I went to work in heels but put on my trading jacket and my Danskos on the trading floor. My heels slipped smoothly back onto my feet at the end of the day. I might have wanted to wear heels all day, but I had to be practical.

Even though I was outnumbered on the trading floor, being a woman didn't define me. It did, however, help me stand out. The NYSE is a tight-knit community that supports and learns from one another. We made decisions and resolved mistakes quickly. Like the gaggle in a crowded New York City subway, we were bound to get pushed and jostled, but, amid this seeming chaos, we helped each other do the best jobs we could to serve our clients.

I never questioned whether I belonged in that environment. It was fun, and I was good at it.

I left the Exchange for a while and took a break to go to culinary school, another profession where my Danskos served me well. After a short stint at another exchange, I returned to the NYSE, this time as part of the Exchange executive team. While I traded in my Danskos for heels, I keep them proudly as a reminder of my journey.

As president of the world's largest stock exchange, I have the privilege of working with CEOs, entrepreneurs, elected officials, and the occasional celebrity to demonstrate that you can be yourself in the workplace. While I often wear a pair of black Prada pumps, I never hesitate to wear shoes that have pops of color or pattern. A recent favorite is the pair of polka-dot shoes that were a present to myself after becoming president. I've always been confident in who I am, and I'm proud to have that reflected in my shoes.

STACEY CUNNINGHAM Stacey Cunningham was named the sixty-seventh president of the New York Stock Exchange in May 2018—the institution's first woman leader. She rose from a trading-floor clerk to an NYSE specialist trader before serving in a number of senior roles at Nasdaq and the NYSE. Cunningham served as the chief operating officer of the NYSE from 2015 to 2018 and is also a trained chef.

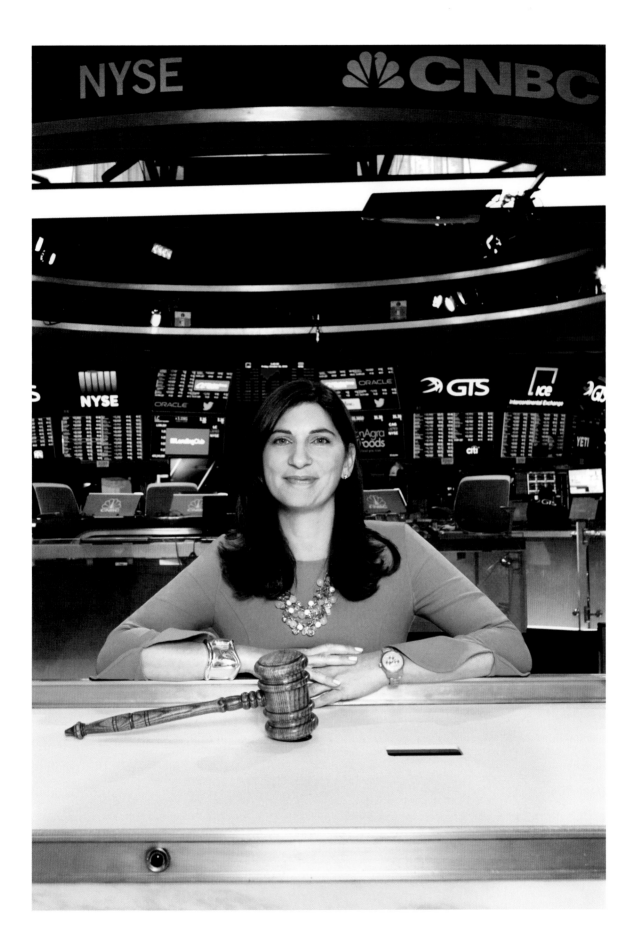

WENDY DAVIS

FORMER STATE SENATOR, TEXAS

In the state of Texas, the filibuster is a test of physical and mental endurance. You're required to conduct it on your own, not allowed to leave for a bathroom break, or eat hard candy, or take a sip of water, or sit or lean on your desk.

I had already conducted a filibuster in 2011, but it was a short one, just a little over an hour, and I had worn a pair of black patent-leather Tory Burch flats. I was known for my high heels; they were my source of power—standing tall and owning my femininity 100 percent. Never a day went by without my rocking a pair of high heels. When I showed up with my flats to filibuster that day, people knew something was up.

My second filibuster occurred when, in 2013, a bill came before the State Senate that would target regulations of abortion procedures, basically making abortion clinics provide many more complicated medical services that would be very expensive and prohibitive to enact. I was chosen by my caucus to lead the filibuster to prevent the bill from being voted on. We only had forty-eight hours to prepare for it.

The morning of the filibuster, in June 2013, I ate a single boiled egg for breakfast. I listened to Bruce Robison's "What Would Willie Do" to help me put things into perspective and calm my nerves. And I was fitted for a catheter by a doctor who came to my apartment to help me prepare for the day. As I was walking out the door with my same Tory Burch flats, I decided that something more supportive might be needed, prompting me to run back in to grab my running shoes instead: pink Mizuno Wave-Runners. When I bought them, I thought, *Oh my God, pink is so not me*, but they were the only pair that came in my narrow size, so I bought them.

My staff and the staffs of my Senate Democratic colleagues had prepared binders that would fill the almost thirteen hours of talking, because we knew that anything said had to be germane to the argument, another rule of the Texas Senate. I worried about getting hungry or thirsty, but once I began I never gave food or water a second

thought. Instead, I was focused on reading the stories of real women who had made abortion decisions in their own lives, women who were willing to share something deeply personal to stop the terrible bill I was standing against. Throughout the day, thousands of people made a pilgrimage to the Texas capitol to support me.

My lower back did begin to hurt from standing in one place for such a long time, so a colleague helped me strap on a back brace, which resulted in my getting called out on a point of order! I could only sustain three points of order before the filibuster would be called to an end. It didn't take long to realize that my senate colleagues on the opposite side of the issue were bent on making that happen. And, sure enough, at around 10:45 P.M., after two more unwarranted points of order were ruled against me, the filibuster was called to an end.

But when the lieutenant governor then attempted to call for a vote on the bill, something magical happened. The thousands of people who had gathered in support of what I was doing rose and began to roar. Throughout the Senate gallery, up and down the hallways of the capitol, and on every level of the rotunda, they screamed with everything they had. And it was because of them, because of their raised voices and pounding feet, that we were able to prevent a final vote on the bill until after the midnight deadline had passed.

I remember thinking that showing up in sneakers on the Senate floor that day instead of my traditional kick-ass heels would feel like I was giving up some of the power that my shoes normally gave me. To my surprise, though, the image of me in pink sneakers went viral. And the shoes took on a meaning all their own. Retailers all over the country immediately sold out of the shoes.

When my two young granddaughters are old enough to understand, I'll tell them the story about my pink sneakers. I'll tell them about the importance of being in the arena fighting, rather than sitting things out on the sideline because we are afraid to stand up for something we believe in. Most important, I'll tell them what it means when we decide we are going to join together and push back when we know women's lives are on the line.

—*AS TOLD TO AMANDA BENCHLEY*

WENDY DAVIS Videos of Wendy Davis went viral in 2013 when she stood on the floor of the Texas Legislature for eleven straight hours; a famous filibuster that blocked the vote for a bill restricting abortion access that was scheduled for that day—though it later passed. A three-term state senator, Davis is also a lawyer and ran for Texas governor in 2014. She has written a memoir entitled *Forgetting to Be Afraid* and is the founder of Deeds Not Words, a nonprofit that engages young women in politics.

KATE DiCAMILLO

AUTHOR, CHILDREN'S BOOKS

I grew up in a small town in Central Florida in the 1970s and '80s, and when I was a teenager, I subscribed to *Seventeen* magazine. Every August, *Seventeen* would arrive with glossy layouts of back-to-school outfits—tartan skirts and sweaters and Frye boots. And I would sit in the sweltering heat that was Florida in August and study the clothing, and the boots, and think: *Oh, this is what grown-ups wear; this is what I will wear when I'm sophisticated and grown up.*

And so I grew up.

I did not, however, become sophisticated.

But I did get to become a writer.

My first novel was *Because of Winn-Dixie*. It's the story of a girl and a dog and a small southern town. An amazing thing happened with that book—people just kind of opened their hearts to it. And that is a wonderful and terrifying thing if you're a writer. It's wonderful because you make deep connections with readers; it's terrifying because you think: *Oh, I have to write another novel just like that one so that people will keep loving me.*

I tried and tried to write another book like *Winn-Dixie*, and I finally figured out that if I was going to survive as a writer, I *couldn't* write another book just like *Winn-Dixie*. Instead, I needed to go in a totally different direction.

And so I wrote a story set in a castle, a story about an impossibly small mouse (with very large ears) who has to be brave.

That book is *The Tale of Despereaux*. It was published in 2003, and in 2004 the American Library Association awarded it the Newbery Medal (receiving the Newbery means attending a ceremony and wearing a gown . . . but we're not talking about gowns, we're talking about shoes), and then the book became a movie.

And for the movie, I had to do a press junket and also walk the red carpet for the premiere.

I thought, *Oh boy, how am I going to do this? How am I going to do these big grown-up, sophisticated things that seem impossible?*

And that's when I remembered *Seventeen* magazine and the Frye boots.

I thought, *I know what I'll do. I'll get some Frye boots.*

And I did.

I wore the boots for the press junket, and I wore them on the red carpet. I wanted to feel like myself, but I also needed to be brave. And so I wore jeans and a kind of sparkly sweater.

And the boots.

In them, I could walk the red carpet with (gulp) Emma Watson and Sigourney Weaver, and do a press conference with (eep) Dustin Hoffman. It was all very surreal, but I felt like I could do it because the boots made me feel like I could do it.

The movie adaptation of *The Tale of Despereaux* came out in December 2008.

In January 2009, my mother became very sick. She was in the hospital for two weeks. And every morning, I woke up and thought: *How can I get through this? How can I be brave enough?*

And then I would remember the boots.

I put the boots on and wore them to the hospital.

And when my mother passed away a few weeks later, I wore the boots to the funeral.

I haven't worn them since.

But the boots gave me what I needed.

They reminded me that I have it in me to be brave—to do things I never thought I could do.

KATE DICAMILLO Kate DiCamillo has won two Newbery Medals for the most distinguished contributions to children's literature, first for *The Tale of Despereaux* in 2004 and then for *Flora & Ulysses* in 2014. Her first book, *Because of Winn-Dixie*, was adapted to the well-received film in 2005, followed in 2008 by the equally successful rendition of *The Tale of Despereaux*. The author or coauthor of more than twenty other beloved children's books, including the Mercy Watson and Blink and Golie series, she was also appointed by the Library of Congress to be the National Ambassador for Young People's Literature Emerita.

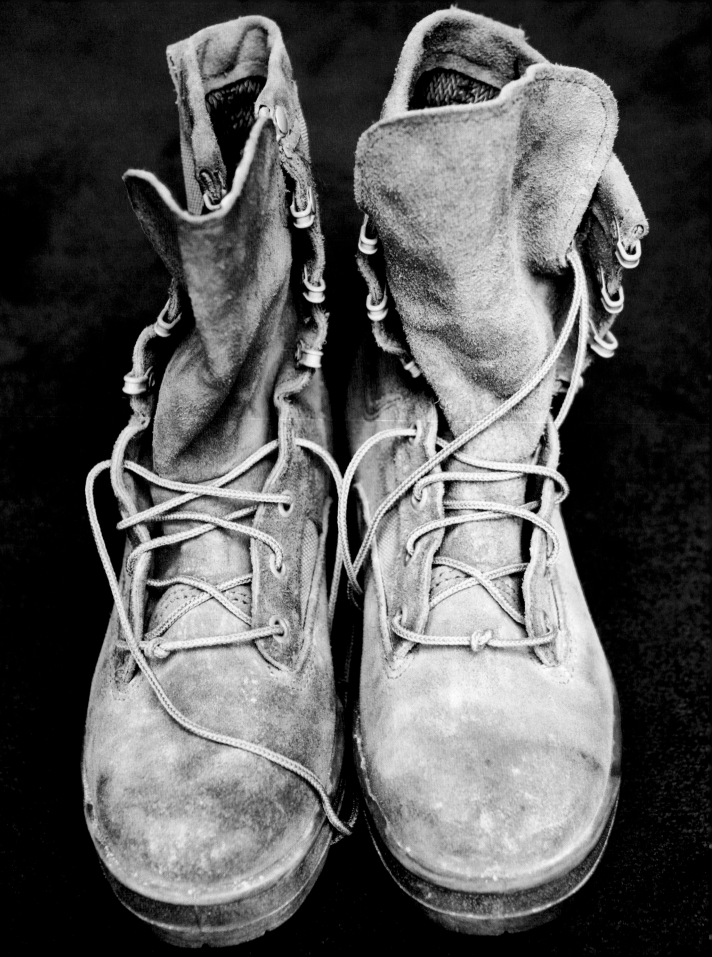

SENATOR TAMMY DUCKWORTH

UNITED STATES SENATOR, ILLINOIS

Shoes are superfluous in my life now because I have no feet. I spend most of my day in my wheelchair, and I do not often wear my right prothesis, so I pretty much wear the same shoe with everything.

I retired from the military in 2014 and have gotten rid of most of my old things, including my old uniform, but I just can't bring myself to get rid of a pair of boots from Iraq.

My helicopter was shot down in Iraq in 2004. After spending more than a year recovering at Walter Reed Army Medical Center in Washington, D.C., I went to retrieve my footlocker, which had been packed up and sent back to Illinois after I was wounded.

Driving my Ford F-150 to the hangar of an old National Guard unit where it had been stored, I got the same feeling that I have now every time I go into a military post, and especially a helicopter hangar.

It's bittersweet. I see the aircraft, smell the hydraulic fluid and the fuel. I see men and women who right now are who I was before I was shot down. As much as they embrace me, I'll never be a part of that again. It's not easy and it hurts, but it's also something I am proud of.

It was an old plastic footlocker that had my name stenciled on it. Somebody went in, cleaned out my gear, and pulled out the stuff that they did not think my family should see, and then all my personal belongings got sent home.

That day, when I unpacked my gear, I saw those boots, covered in that specific, fine dust from Iraq. The sensation of the dust and the smell of boots set off an intense flashback of being there, back in the desert.

The boots were part of my uniform, part of who I was. They were flame-retardant and standard-issue, but used especially by air crews. They represent everything about who I was as a person when I wore them. The smell of Iraq, the dust, and the memories come with them.

I can't bring myself to get rid of them. I can't even bring myself to clean them off. So they sit in my closet in Illinois, with the dust still on them, next to a pair of running shoes that I also wore in Iraq that have the same dust.

The physicality of me, I guess, is what these shoes represent. That's what prevented me from getting rid of them like I have gotten rid of everything else. They are not suitable for me to wear with prostheses, and I wasn't sentimental about getting rid of everything else, but I look at the shoes sometimes and I do not know what to do with them.

My entire identity as a person was as a soldier, and even my recovery was about being a good soldier. My recovery became my mission. I got into public life because I was a soldier who needed a new mission, which was to help veterans. Now, I have two beautiful daughters and this amazing job where I get to make a huge difference in the world for my buddies. The boots, though, are a reminder of who I was before I was wounded. It might as well be me sitting there instead of the pair of boots.

—*AS TOLD TO AMANDA BENCHLEY*

SENATOR TAMMY DUCKWORTH Senator Tammy Duckworth is a Purple Heart recipient and the first female double amputee from the Iraq War. A retired lieutenant guard and helicopter pilot, she lost both her legs when her helicopter was hit by Iraqi grenades in 2004. She was elected to the House of Representatives in 2012 and then to the Senate in 2016, where she now serves as Illinois's junior senator and as a member of the Energy and Transportation Committees. She also served as the director of the Department of Veterans Affairs in Illinois.

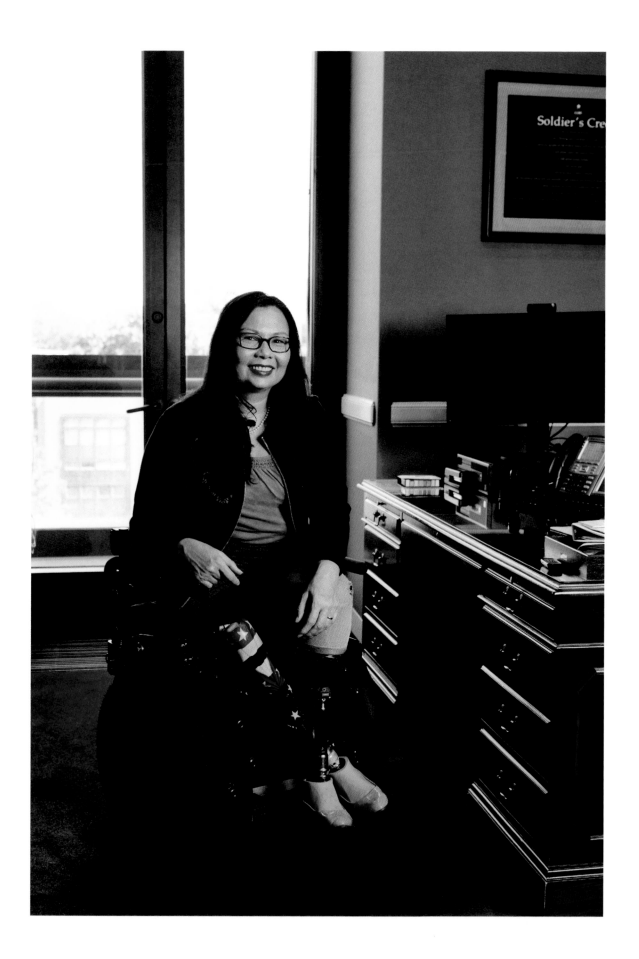

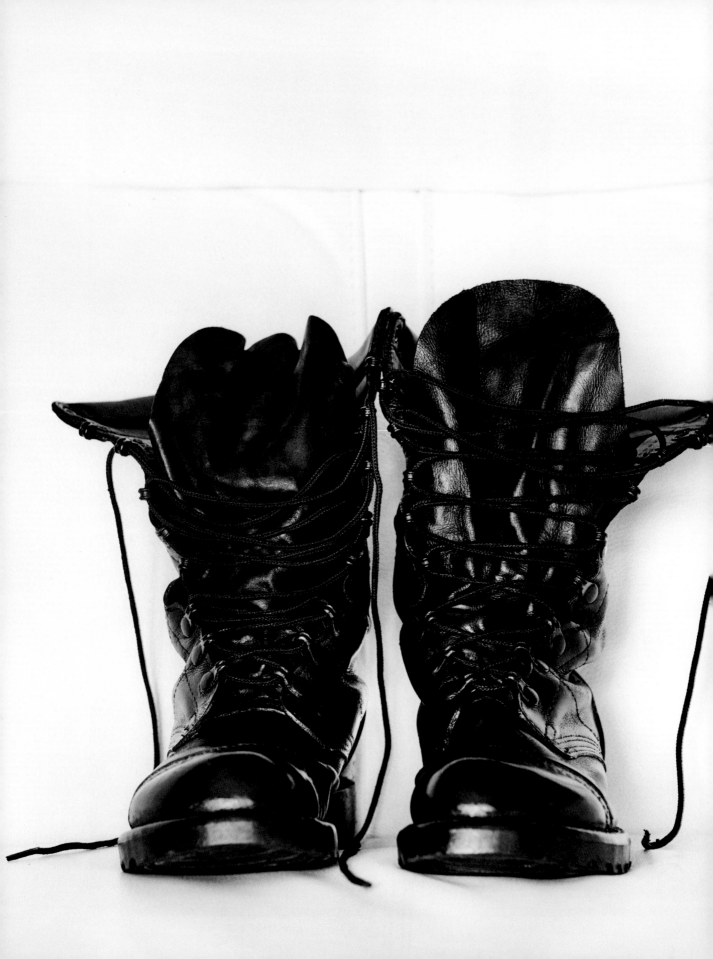

GENERAL ANN DUNWOODY

FOUR-STAR GENERAL, U.S. ARMY

O ne of the proudest days of my life was the day I graduated from the United States Army Airborne School, in 1976. In order to graduate, you needed to complete two weeks of intense preparation and training, followed by five jumps at 1,250 feet from a U.S. Air Force transport airplane. And from that point forward, every time I was assigned to a job where parachuting was one of my duties, I wore Corcoran jump boots. These boots are legendary. Paratroopers count on their leathery toughness, increased ankle support, and unique design.

I had been a physical education major in college and always thought I was going to be a PE teacher. I came from four generations of West Pointers, but West Point wasn't open to women then. In my junior year, the Army was trying to recruit more women. If you qualified, you got a stipend of $500 a month during your senior year of college and then you committed to two years of service.

So I joined the Army. I loved being a soldier and meeting soldiers, and I remember thinking that I was going to stay as long as I could, and make a difference. I moved up the ranks one job at a time. I had thought my childhood dream was to be a PE teacher, but it turns out I realized it in a different profession, on a different kind of battlefield.

I first went through eight months of training in the Women's Officer Orientation Course, and then got to choose which basic branch of the Army to be in. I chose the airborne division. It was physically challenging and exciting, and it sounded like it would be a great adrenaline rush.

I was scared the day of my first jump, but, more than anything, I was thrilled. The chance to jump out of airplanes was a primary reason I joined the Army. I felt trained and ready, and thought I must be doing really well, because the jump master informed me that I was going to be the first paratrooper out of the plane. When I asked him why, the sergeant snorted, "Lieutenant, if the men see you jump, they won't dare chicken out."

Back in those days, the boot was all leather, but the toe and heel leathers had an upgraded finish that allowed them to be spit-shined and polished so that they glistened.

Corcoran jump boots, however, are not for jumping. They are really more ceremonial and worn on formal occasions—no one wants to lose that shine and have to start over, trying to spit-shine scarred or damaged boots.

The Corcoran jump boots, the wing pin that every paratrooper wears, and the distinctive maroon beret are symbols of excellence. These boots represent the pride and sense of camaraderie that have been the hallmark of my service.

Being an Army paratrooper was one of the most memorable accomplishments of my life. I've met and worked with great soldiers in the airborne community. I even jumped into Normandy on the fiftieth anniversary of D-Day, in 1994. I still smile every time I see or think about my old Corcorans.

—AS TOLD TO AMANDA BENCHLEY

GENERAL ANN DUNWOODY The first female four-star general, Ann Dunwoody served more than thirty years in the United States Army and Armed Forces. Among her responsibilities were as commander of the Army Material Command, one of the largest branches of the Army, and as a division parachute officer. Dunwoody is from a dedicated military family with four generations of West Point graduates: her father was an Army officer and her sister and niece served in the Air Force.

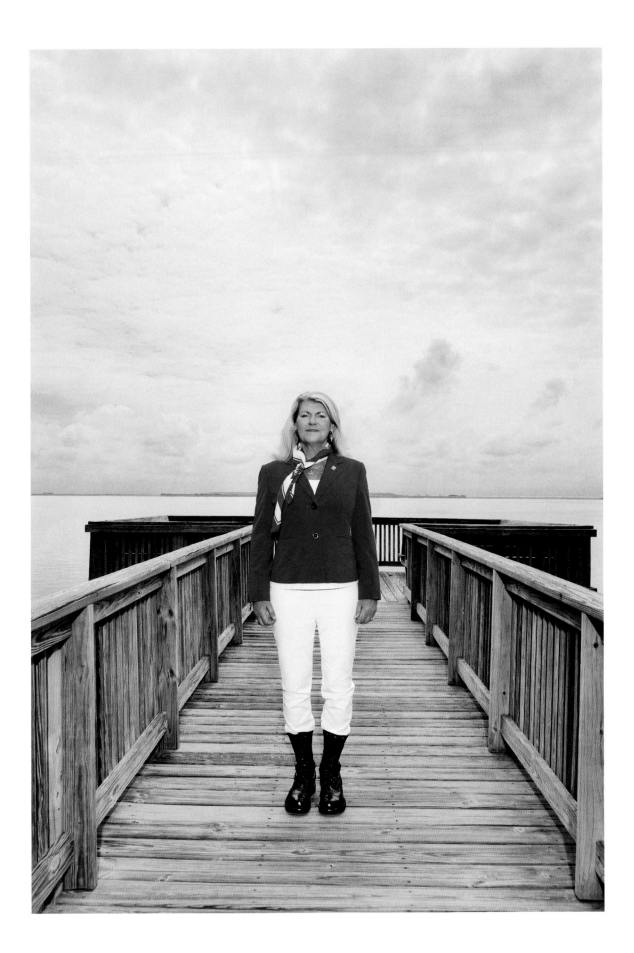

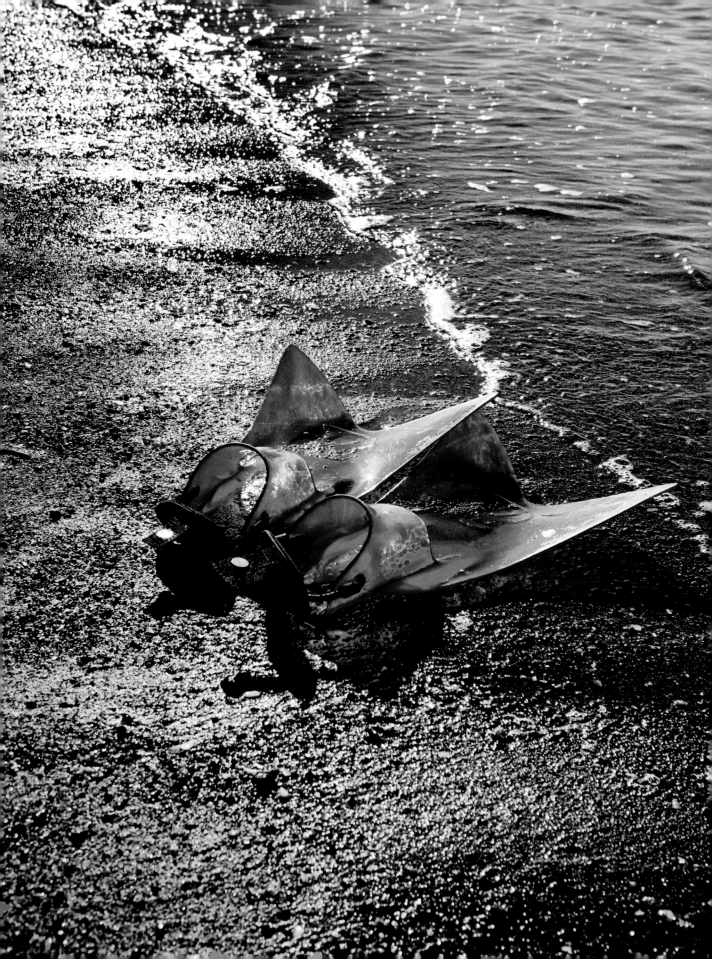

SYLVIA EARLE

MARINE BIOLOGIST & EXPLORER

My longtime friend Bob Evans makes these extraordinary flippers called Force Fins. They're called that because the United States Navy special forces have adapted them for their regular use, but in black of course. They also come in green, blue, and gold, and sometimes with sparkles. The ruby ones like mine are displayed at the Museum of Modern Art in New York City.

They're nice to look at, but they really are designed taking the natural attributes of fish fins or dolphin fins into account. They're just flat, curved, and flexible, which makes it possible to maneuver around delicate things such as branches of a coral.

Some of the long fins are great because they give you superpower when you're moving fast, but if you want to do what I often love doing, which is just to move quietly and with great dexterity among fragile things without bumping into them, these ruby slipper Force Fins are really ideal.

Bob gave me my first pair in the 1970s and I take them on all my expeditions. But the ruby slippers really caught my attention in the 1980s, when my daughter was wearing a pair in the Galapagos.

"IF YOU CLICK YOUR RUBY FLIPPERS TOGETHER, YOU'RE NOT GOING TO WIND UP IN KANSAS, BUT YOU MIGHT WIND UP IN THE OCEAN SOMEWHERE."

The sea lions were entranced by her ruby flippers. They would latch on and bite her flippers and then toggle with them. The way the flippers caught the light made it possible for me to spot my daughter among all the other divers in the water. The ruby flippers really were spectacular—like jewels. I thought, she's wearing ruby flippers like the ruby slippers of Dorothy in *The Wizard of Oz*. If you click your ruby flippers together, you're not going to wind up in Kansas, but you might wind up in the ocean somewhere.

I'm always wearing the ruby slippers in the films for Mission Blue and the National Geographic film *Sea of Hope*. We call our expeditions "Ruby Slipper Expeditions" when we are exploring Hope Spots. They are easy to pack, they're flexible. If I have to go somewhere for diving and can only take carry-on gear, I always pack my favorite mask, my favorite wet suit, and of course my favorite fins and snorkel. I can do that and be prepared for days on a boat and even for a party.

I have had more than thirty pairs of them. I have given some away to my special diving friends, my three children, and my grandsons. I've signed them and auctioned them off sometimes for a benefit to raise funds for the Explorers Club or for the Ocean Elders or for Mission Blue. The highest price was $10,000, for the Explorers Club. I just know I'm in a good place when I'm wearing the ruby flippers.

—AS TOLD TO AMANDA BENCHLEY

SYLVIA EARLE Sylvia Earle is a deep-sea diver, oceanographer, and marine biologist who's been studying the ocean and her creatures since the 1950s. In 2008, she started Mission Blue, a nonprofit dedicated to saving and restoring what she calls the "blue heart" of the planet: the ocean. Mission Blue develops submersible ocean laboratories and establishes marine protected areas around the world known as "Hope Spots.".

CINDY ECKERT

CEO, THE PINK CEILING

In 2011, my company—Sprout Pharmaceuticals—took on getting the first-ever female sexual desire drug approved by the FDA. Pretty quickly, people started to identify it as "the little pink pill." Frankly, the only thing missing when they would say that in a singsong voice was the dismissive pat on my shoulder. By 2015, there were already twenty-six FDA-approved drugs for male sexual dysfunction and not a single one for women.

In instances like that, instances in which you are confronted with obvious gender bias, you basically have two choices. Either you reel back in frustration and self-doubt, or you go right toward it.

I went right toward it. I started to show up at FDA hearings in blazing hot-pink outfits because, dammit, we were going to have that conversation. By that time, I'd spent years listening to the heart-wrenching stories of women affected by sexual dysfunction, and it was about time others did, too.

So I made a decision to dispute the FDA. In response, they opened their doors to women and experts in the field of sexual medicine and listened. Once that happened, once the room was "painted pink" with the actual voices of patients, the tide finally turned to the answer science had been giving all along. In August 2015, the drug was approved. Science won. But in turn so, too, did women.

Then my tiny little company that could was approached by a global pharmaceutical giant who offered to buy the company and march the drug across the globe, making it broadly and affordably accessible to women through their deep resources. All of that *and* they'd keep the entire team. One day after the approval, we announced the deal—they bought us for one billion dollars.

And yet there wasn't a billion-dollar happy ending. Within months of that announcement, the acquiring company had an internal shakeup. As Mama Bear to my team and this brand I loved, I was vocal about my concerns. They invited me to leave, and within months they let most of my team go.

"TODAY ONLY 2 PERCENT OF VENTURE MONEY GOES TO FEMALE-FOUNDED COMPANIES. TWO. PERCENT. WE'RE SAYING THAT HALF THE POPULATION HAS ONLY 2 PERCENT OF THE GOOD IDEAS? RIDICULOUS."

I was heartbroken. I went out to California and was wandering around for some retail therapy when I spotted these blazing neon-pink Christian Louboutin stilettos. I'd never splurged on a pair before, and it was like they called to me from across the store. When I picked them up their color name said it all. Shocking. Pink. That moment was a reality check that my mission wasn't over at all. I needed to buy these shoes and get back to freaking work. Crashing the pink ceiling had been the story of my life, even shocking people along the way—as an out-of-place female entrepreneur, as a woman who took on the first sex drug for women, in every boardroom, C-suite, or moment at the deal table I'd ever faced. Shocking pink was who I was and what my best work would continue to be.

Just months later I opened the doors to the Pink Ceiling and the first ever "pinkubator" to help fund and foster companies by or for women. Today only 2 percent of venture money goes to female-founded companies. Two. Percent. We're saying that half the population has only 2 percent of the good ideas? Ridiculous. I'm going to do my part to change that and create a legion of other women who also pay it forward.

It's funny . . . people often ask me what I bought after selling my company for a billion dollars. My answer has always been "a kick-ass pair of shocking-pink stilettos." The truth is, I've spent my money on something way more important—I've bought into the dreams of remarkable women who are going to change the game through their outcomes. In their honor, I have a small plaque on my desk that says: "She packed up her potential and a great pair of shoes and set out to change the world."

CINDY ECKERT A self-made serial entrepreneur and vocal advocate for women, Cindy Eckert defies convention. Her work today at the Pink Ceiling—an investment firm, "pinkubator," and consulting enterprise—breaks traditional barriers by investing in and mentoring other women and their business ideas. Over a distinguished twenty-four-year career in health care, she has started and sold two businesses for more than $1.5 billion.

DR. MAE JEMISON

ENGINEER, PHYSICIAN, & NASA ASTRONAUT

One spring morning in 2017, I broke the heel on my favorite pair of shoes just before delivering an important speech—fostering humility and a deep sense of pride.

I was energized and set to discuss the pursuit of radical innovation with a conference of 150 high-octane CEOs and other influential women. The 100 Year Starship initiative to achieve the capabilities for human travel beyond our solar system, which I lead, was the catapult. And I had on my go-to, badass shoes. I was ready.

Of course, as a woman presenting to women, shoes matter. Hate to play into stereotype—but they do. Wearing high heels conveys a sense of power and self-assurance, especially when speaking about science. The shoes don't have to be stilettos, but definitely "high" heels. And for me, comfortable, so you can stride with ease and purpose.

My choice: a pair of beautiful spectator slingbacks. Black patent toes, flat black leather body with well-proportioned three-and-a-half-inch beige crocodile-embossed leather heels. I give a lot of speeches, and these were "the" shoes to be jazzy and comfortable in while wearing black.

The setting was an intimate amphitheater-style classroom with the stage at the bottom. Wonderful, except for the absence of handrails and a center walkway of uneven steps—which I knew, because I had already navigated them earlier to take my computer to the stage. My introduction was precipitous without warning, with me still at the top of the theater. And as I gracefully walked down—you know, Miss America–style without looking down—my heel caught somehow, and I stumbled. I straight-up fell. I watched as it happened.

I thought, *Just don't roll!* Bouncing back up immediately, I smiled and kept going. (I think having been a dancer all my life helped with stage presence and the ability not to wallow.)

Some in the audience gasped, others tried to see what happened, while a few pointed out that my heel was broken. The organizers wanted to know if I could give the talk or needed first aid.

No way to play it off.

With a turned ankle and scrapped shins burning underneath my pants, the first line in my speech changed to "Well, now I've checked 'falling down in front of an audience' off my bucket list." Everyone laughed, some nervously. I took off my shoes and said, "Let's go." I gave the speech in front of this august group of women in my stocking feet.

The fall was forgotten; the shoes put aside as I walked the stage and did my job. Because that's what was important in the scheme of things—delivering the message, no matter the trappings. My job that day was to show the power of pursuing something truly extraordinary tomorrow, that we do not know the answers to lead to a better world today. Even if I was thinking, *Aw hell, I just broke my favorite pair of shoes and I hope I can fix them,* or *Is my leg bleeding through the pants?* and *I hope no one got that on video,* or any number of crazy things, my actual job was important.

Things happen in life. Our shoes go with us. What we wear on our feet in some ways represents who we are. But our shoes are not us. They are part of a costume. In that amphitheater that spring, I had my power shoes with me, but most important, I had myself.

DR. MAE JEMISON Dr. Mae Jemison is at the forefront of integrating the physical and social sciences with art and culture to solve problems and foster innovation. Jemison leads 100 Year Starship®, a global initiative to ensure the capabilities for human travel to another star within the next hundred years while transforming life on Earth. Jemison served six years as a NASA astronaut and was the first woman of color in the world to go into space.

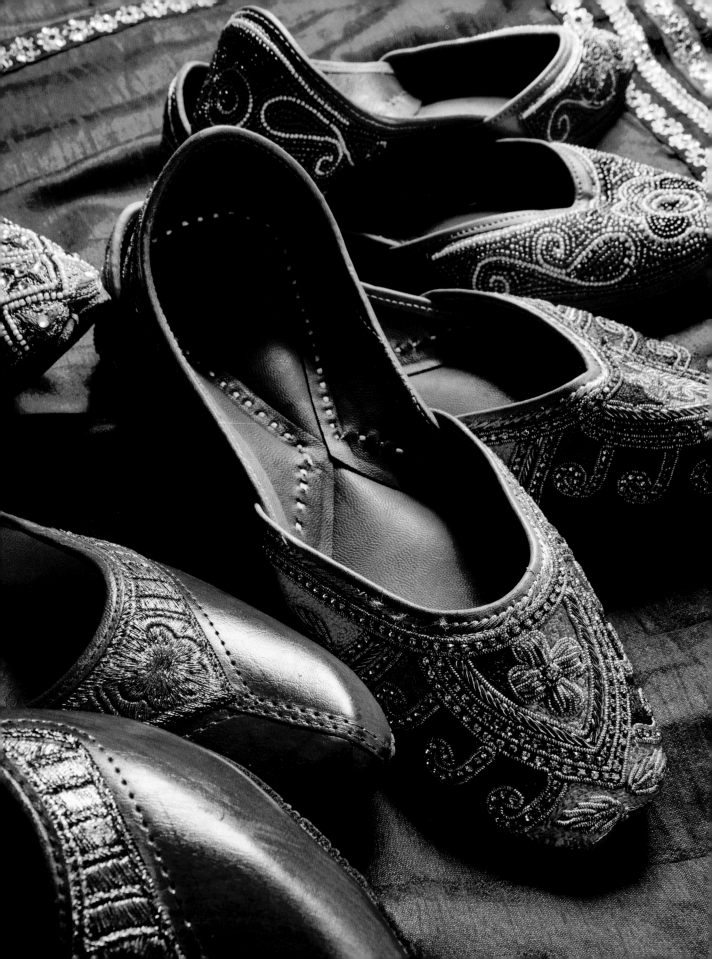

RUPI KAUR

POET & ARTIST

lue. Green. A streak of yellow gliding across the middle like Helios's Chariot. The colors seem splattered—but in the good kinda way, and they have the ability to transform any canvas—like a meticulously crafted mural on a freeway underpass.

I'm not sure when I first put them on. I wouldn't really know, either. They originally came from my mother. My father was far gone in a search for a land to call his own, because the land he'd grown up in now no longer had a need for him. So it was up to my mother, in the first few years of her marriage, to conjure ways for her daughter to look beautiful. Or at least presentable. It's what so many mothers across the world—who are full of imagination but with no means to make true any of those imaginings—do every day. They end up the world's most enterprising accountants.

My mother would barter away a few things here and a few things there—until that blue, green, and chariot yellow lay at my feet. Three-year-old me must have placed them on—reluctantly, because, to tell you the truth, even now they fit a bit rough.

They are Punjabi Juttia—boldly colored leather-crafted shoes that easily become the highlight of any festive function. Since the old days they've become a staple of my outfits, in rural Punjab, basement bedrooms, college dorms, and eventually houses. I wear them on tour, at parties and weddings, on casual strolls at home, or on my travels. I've even begun to see them refashioned and reshaped for Western wear by those brands that always take the most culturally relevant elements of a people and re-create them for Western wallets.

"BLUE. GREEN.
A STREAK OF YELLOW
GLIDING ACROSS
THE MIDDLE
LIKE HELIOS'S CHARIOT.
THE COLORS SEEM
SPLATTERED—BUT IN THE
GOOD KINDA WAY,
AND THEY HAVE THE ABILITY
TO TRANSFORM ANY
CANVAS—LIKE A
METICULOUSLY CRAFTED
MURAL ON A
FREEWAY UNDERPASS."

RUPI KAUR When Rupi Kaur graduated from college, she couldn't find anyone to publish her powerful, poignant poems and the accompanying whimsical line drawings. So the then twenty-two-year-old turned to Instagram, quickly becoming a sensation and attracting more than two million followers. It wasn't long before the mainstream publishing industry took notice. Her first collection, the originally self-published *Milk and Honey*, sold millions of copies and by 2017 had soared to number one on the *New York Times* paperback trade fiction bestseller list, where it was later joined by her second collection, *The Sun and Her Flowers*.

PADMA LAKSHMI

AUTHOR, ACTRESS, & TELEVISION HOST

I have two sides to me: the twenty-course tasting menu, shopping in Paris, uttering numerous Kafka-length sentences at a time side, and the down-in-the-dirt, eat at any street stall in Delhi, sleep with and keep on last night's makeup, curse-like-a-hooligan side. One side usually drives while the other puts its feet up and waits for a more suitable terrain to spread its wings. But when those two selves are allowed to join in one being, it's often hard to figure out what to wear. The one beloved standby in my closet that always fits is a pair of Azzedine Alaïa shoes.

Years ago, I discovered a little Parisian shop that sold Alaïa at a discount. I instantly loved these pumps: cream-colored animal print, with black leather and lizard trim. They were idiosyncratic and quirky. They were what the French would call *jolie laide*. Best worn with all black.

I once wore them to Madison Square Garden to watch the Knicks. Miraculously, the Knicks won. If you're a Knicks fan, you know this is indeed rare. I was having dinner with a friend named Lee O'Denat, who went by the nickname Q (he has since passed away, from a heart attack). Q said to me, "It's the shoes, you gotta *always* wear those shoes!" But the shoes were an extravagant and unlikely choice for a sporting event.

Q and I were an unlikely pair too. I first met him one fall night at a basketball game with my daughter. I sat down next to a very large, bald African-American man in sunglasses. Clutching a Big Gulp–size Hennessy and ice, he had on lots of gold hardware. "You look like that girl from my favorite TV show." I had the extreme pleasure of informing him, "I *am* that girl from your TV show!" He couldn't believe it, making it a point to ask me every question he'd ever had about *Top Chef* and TV production. He was so charming and funny. He made me laugh so hard, I thought I'd pee in my pants. We were fast friends.

Lee was from Queens, like me. Every now and again he treated himself to really great seats. He ran a successful and very questionable website called

WorldStarHipHop, which I had never heard of. He invited me to sit with him in the same seats two days later. He became my new best friend. Over the years, our relationship would grow and blossom. We always met at the game, we always sat in the same seats, and I always wore the Alaias.

Q was so removed from my life, it became easy to let myself go with him. I'm not a big drinker, but with Q I managed to guzzle two double vodkas before halftime and still stand, even in those shoes. We confided all our worries and hopes. Our lives never met except at Knicks games or when he visited me on *Top Chef*, coming into town like Santa Claus, bearing oversize stuffed animals for my daughter or taking us to see The *Lion King* on Broadway with other kids from his charity. He would drop in and out of contact but somehow always be there, even if only by phone. Lee would ask me for parenting advice; he had kids, even a daughter the same age as mine. He was my Yoda on youth culture, while I was his history and general knowledge professor. We delighted in each other and became like carousing teenagers. He pushed me to be my rowdiest self because he knew I had no other outlet to do that. I pushed him to listen to his instincts and reminded him that while he may never have finished high school, his innate business sense had propelled him to where he was, that the other stuff he lacked could easily be learned.

As in all good friendships, we encouraged each other to be our whole selves. We came together in such an unlikely way that we understood the value of our friendship. Q was never inappropriate, never pushed me to date him, and listened supportively. I never admonished him for his website, which, as a feminist and mother, I found atrocious. That was his business. I had no right to judge him, and I didn't.

Now every time I see those Alaïa shoes in my closet, it's Lee I think of. I remember him saying, "Pads, you got to live a little! There's more for you, I know it." But with Q's passing, there is certainly less in the world.

PADMA LAKSHMI Padma Lakshmi is internationally known as an actress, food expert, model, and *New York Times* bestselling author, as well as for being the recipient of the 2016 NECO Ellis Island Medal of Honor and as ambassador for the ACLU. Nominated for an Emmy award for her role as host and judge on Bravo's Emmy-winning *Top Chef*, Lakshmi also serves as an executive producer. She is an avid New York Knicks fan.

LAUREN BUSH LAUREN

CEO & COFOUNDER OF FEED PROJECTS

I had just graduated from college and was in Paris with my brother and my boyfriend at the time, who is now my husband. It was a beautiful day, and we were just wandering around and stumbled upon this random sneaker store. They had a pair of leather Converse sneakers, which I had never seen before, in the perfect brownish-tan color. Little did I know when I bought them just how much I would wear them.

To me, these shoes represent this time in my life post-college and the early days of FEED, the excitement of being a young entrepreneur figuring it out and hustling. I had started traveling with the UN World Food Programme when I was a sophomore in college, meeting communities and kids born into a life of extreme poverty and hunger. I thought, *There has to be more I can do to help than just spreading the word to other students.* It was very transformative for me. Around my junior year, I had the idea for the first FEED bag, and by the end of my senior year I had the first prototype. I had graduated with this idea in mind but still didn't know how to make it happen from there.

After graduation, my first apartment in New York City was with three friends—a sixth-floor walk-up on the Lower East Side—and we were all crammed in. I took the risk of seeing if this FEED thing could happen before I got a real job. Most of my friends had proper jobs at investment banks and places like that. It was an exciting but nerve-racking time, sitting in my apartment, hoping to make this philanthropic business happen, and asking myself, have I made the right life and career decision?

In the early days of FEED, it was just me working out of that apartment. I'm not really a heels kind of gal. It was just practical, I needed flats. I wore the Converse

sneakers every day. The shoes themselves connote a kind of cool casualness, but the leather makes them more durable and slightly fancier.

I'd wear them traipsing around to meetings in New York, on the subway, on planes. I wore them on trips around the world with the UN World Food Programme, I'd wear them to business meetings and more casual meetings, to make a speech. I even wore them to the airport to pick up our first order of bags coming in from China, when we were laughed at because we didn't have a customs broker.

I luckily had modeled a little through high school and college, so I had a bit of a financial buffer. But I had given myself a six-month period before I would need to get out there and find a "real" job. It was so scary. My parents were nervous and I was nervous. Living as frugally as you can in New York City isn't that easy. And I just started hustling, showing the bag to different folks and hoping to get into even one store, because this was before online shopping was a big thing.

I didn't set out with a proper business plan. I just thought, gosh, if I can make one bag and sell that bag and help feed one kid for one year, then great. Our first order was for five hundred bags from Amazon, and that fed five hundred kids in a school for a year. I truly believed in this idea as something that I, as a consumer, would want to buy and gift to my friends and my family. And I hoped I was not alone.

I've owned these sneakers longer than any other shoes, more than ten years now. I am wearing them sparingly these days because the soles are wearing out and I can't find replacements. A friend of a friend works at Converse and I've sent her pictures, hoping they will make them again.

—AS TOLD TO AMANDA BENCHLEY

LAUREN BUSH LAUREN Named one of *Forbes*'s 30 Under 30 Social Entrepreneurs, Lauren Bush Lauren started FEED Projects in 2007 after seeing the effects of poverty and hunger traveling the world with the World Food Programme (WFP). FEED designs and sells products such as their iconic burlap bag, a portion of whose proceeds go to fight hunger. FEED Projects has provided more than a hundred million meals, including school meals in sixty-three countries. Each product has the number of meals it buys stamped on it.

MAYA LIN

ARCHITECT, ARTIST, & DESIGNER

My Dansko clogs are a shockingly unexpected work shoe. I started wearing clogs in college—the wooden kind that made the loudest noise clomping on the stone steps. I discovered the Danskos right after grad school and started wearing them. They are really comfortable, and they work both inside and outside. They are two inches above the ground, so they keep me out of any puddles or dirt when I am on work sites. For years, I never took them off.

I am five feet three, and the clogs are also an easy way to feel a little taller. I can feel a little claustrophobic and small in crowds of people. Part of me feels safer in clogs because I think, *I am here, do not step on me!* And I am terrible in heels, and it is very obvious when I wear heels that I cannot really walk in them.

I think I definitely dress more as an artist than as an architect. As an architect, you are expected to show up in suitable business attire. I think that as an artist, the last thing you want to do is dress up. There is no uniform, and everyone seems to be a little bit more individualistic.

"I DO NOT WANT TO DRESS UP; I WANT TO DRESS FOR GETTING A JOB DONE."

My father was an art professor, and dean of the Fine Arts Department, so I pretty much grew up in the art department creating artwork my entire childhood. I was casting bronzes by the time I was in high school. I studied architecture because I was very good in math and academics, but my whole psyche is that I am my father's daughter. Even the Vietnam memorial is really a work of land art—yes, it is a memorial, but its design is also coming out of a more abstract language of earth art.

I was very young when I started, and the reporters would just write about how petite I was and about the delicacy of my hands. I would dress in oversize men's clothes—I think to the consternation of the veterans, who could not figure out why I wasn't dressing up. I had one suit that I wore once or twice for some of the subcommittee hearings about the memorial. I was so uncomfortable; it was so not who I was. Thank God, I have a loud voice.

I do not want to dress up; I want to dress for getting a job done. This uniform is me announcing, "No, I do not care what you think about how I look, because I have to do what I do." And, in that sense, my uniform is like a costume that says, "Do not look at me, let us just get on with the work, please!"

The contractors on my work site wear work boots, and they will say, "Wait a second, you can't wear clogs, because you are never allowed to have an open-toed shoe on a work site." And I say, "Technically, I can wear them. Because the toe is concealed."

—AS TOLD TO AMANDA BENCHLEY

MAYA LIN Maya Lin was catapulted into the national spotlight in 1981, when, during her senior year at Yale University, her proposal for the Vietnam Veterans Memorial in Washington, D.C., was chosen from more than fourteen hundred submissions—though later she had to defend her design in congressional hearings. She has since designed several more memorials, including the Civil Rights Memorial in Montgomery, Alabama, as well as created award-winning works in both art and architecture. Her artworks are exhibited at museums and galleries, and her stunning earthworks are permanently installed worldwide.

DEBORAH LIPSTADT

HISTORIAN

I got these shoes in 2017, when I was in Warsaw for the Polish premiere of the movie *Denial*, which told the story of my London libel trial, when I was sued by the world's leading Holocaust denier for calling him a denier, racist, and anti-Semite. It was a long, difficult legal battle, and I was scared about the outcome. I should not have been: We won a sweeping victory. Much of the film was shot in Poland, and since so much of the case revolved around Auschwitz, having a premiere in Warsaw was significant.

On a cold January day in 2017, I was walking down a passageway in Warsaw and saw an old-fashioned store, Kielman, whose windows were encased in carved wood. The fine leather goods—boots, belts, and briefcases—in the window evoked quality and elegance. But what also caught my eye was an array of traditional oxfords in vibrant colors—olive and crimson, brown and sapphire blue, black and red, burgundy. I stood there, transfixed by this quirky mix of tradition and modernity.

A lover of well-crafted leather goods, I went in just to look further with *absolutely no intention of buying*. I discovered they had a women's line of shoes, which included the oxfords in the window. They brought out an array of leathers and proposed wonderful combinations. But I thought, *$1,000 for a pair of shoes I really don't "need" is too much of an indulgence, an unnecessary extravagance*. And I left.

I shared the story of my shoe excursion with some of the young people involved in the movie premiere. They were so excited by my description of these colorful yet traditional shoes that they insisted on accompanying me back for another visit. Their excitement was infectious, and I found myself ordering a pair.

I told the saleslady, who, it turned out, was the founder's great-great-grandchild: "Take my order quickly before I change my mind." She called for "The Master." Out came a man in his sixties with white flowing hair, a large apron—the kind worn by Pinocchio's Geppetto—and a big notebook. He had me stand on a page from the notebook. Outlining my foot with his pencil, he took a few measurements with a worn measuring tape. No computer-generated drawings or fancy implements to assess the contours of my feet. It seemed very basic—if not primitive and old-fashioned. During this process, a Brit entered the store. He told me that his suits came from Dege & Skinner (the Savile Row tailors who dress William and Harry), but his shoes came from Kielman. I stopped worrying.

Denial had already opened at the Toronto Film Festival and in North America. This was the beginning of the foreign openings. I knew I would soon visit Switzerland, Belgium, the Netherlands, the U.K., and even Japan. But being in Poland was somehow different. Generally, when I am in Poland I am there to visit places that resonate with genocide and persecution. The shoes felt a bit celebratory. They seemed emblematic of the end of a long journey: the trial, the book, the movie.

Little did I anticipate how comfortable wearing them would be. After traipsing about in them all day, I don't find myself counting the minutes until I can remove them. That "Master" with his pencil and notebook got it perfectly right. They are a combination of elegance, indulgence, and purposefulness.

People often ask me if the trial and now the movie changed me. I don't think they did in any substantive fashion. What they gave me was a chance to stand up to fight the haters, those who spread anti-Semitism and racism and defile history, and to make a difference.

Though this long, drawn-out battle ended well, the fight against haters continued. I am still deeply ensconced in it. But now I get to fight and to teach in a wonderful pair of distinctive, somewhat quirky shoes.

DEBORAH LIPSTADT Deborah Lipstadt teaches Holocaust studies at Emory University and is known for the libel lawsuit against her by David Irving, whom she called a Holocaust denier. The trial judge found Irving to be a "neo-Nazi polemicist" who "engages in racist and anti-Semitic discourse." The *Times* (London) said that "history has had its day in court and scored a crushing victory." Her TED Talk about the trial has 1.2 million views. *Denial*, starring Rachel Weisz, was nominated for a BAFTA as one of the best British films of the year.

SARAH MCBRIDE

TRANSGENDER RIGHTS ACTIVIST

I am on the road giving speeches 80 percent of the time, and these are the shoes that I wear: the black, baby-blue, and bright pink sneakers that I bought in 2013, when I was twenty-two years old. The first pair of sneakers I bought after I came out and transitioned.

They felt so affirming because I finally had a pair of sneakers that matched my identity. When I got these shoes, I never could have imagined the experiences that I would have in them.

I had really boring sneakers when I was growing up—in dull, muted colors. The first thing I noticed when I saw these sneakers was their hot-pink Nike swoosh. They are actually in the colors of the trans flag, which I didn't realize until I started wearing them.

I came out as transgender at the end of my term as student body president at American University, in Washington, D.C., in 2012. That summer, I interned at the Obama White House, and then I returned to school for my senior year. I bought my sneakers for going back to school. I started noticing how many random compliments I got at school about my sneakers. People would say, "Nice kicks," and things like that. I finally had the sneakers that I thought matched my personality.

It was really exciting for me to be able to go back to school as my authentic self. I often think that if trans people don't come out and transition when we're young, we long for a childhood that we were never able to have. When I went back to school for my senior year, I was so unbelievably thankful to have one semester as my true self, which would make up for part of a childhood that I was never able to have.

I started dating my future husband right after I bought the sneakers. He was a transgender man and activist. We met at a White House reception and ended up spending all our time together, fell in love, and then moved in together.

A year after we met, in the fall of 2013, he was diagnosed with cancer. Eventually, he got a clean bill of health in early 2014 and then, in July, he developed a cough that just didn't go away. The same cancer that he'd had in his tongue had spread to his lungs. He had less than a month to live when he asked me to marry him.

I wore the sneakers throughout all the trips back and forth to the hospital. He died three weeks after his terminal diagnosis, and four days after our wedding.

I don't untie my sneakers, so I would just slip them on. It was a chaotic, hectic, and traumatic time. I was trying to do things as quickly as possible, so the sneakers made sense.

I still have them, because they've held up and they were with me at a really trying moment of my life, some of the most difficult times of my life.

They're still pretty vibrant. Since 2014, I've worn these sneakers on probably one hundred flights a year, as I've traveled around the country speaking about trans rights. I think they are a kind of metaphor for what I've been doing: running forward with a sense of urgency.

—*AS TOLD TO AMANDA BENCHLEY*

SARAH MCBRIDE Sarah McBride was the first openly transgender person to address a major party convention, during the election of 2016, at the age of twenty-six. She was also the first openly trans woman to intern in the Obama White House. After college, she helped lead the successful effort to pass gender identity nondiscrimination protections in Delaware. *Tomorrow Will Be Different*, her memoir on her journey as a trans woman, was published in 2018 to rave reviews.

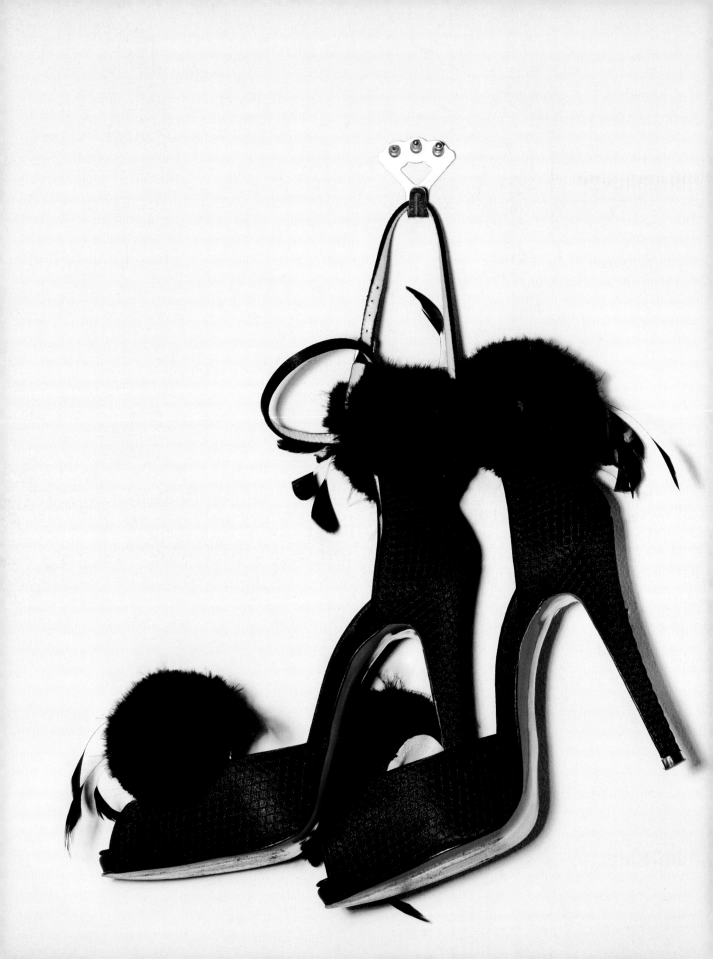

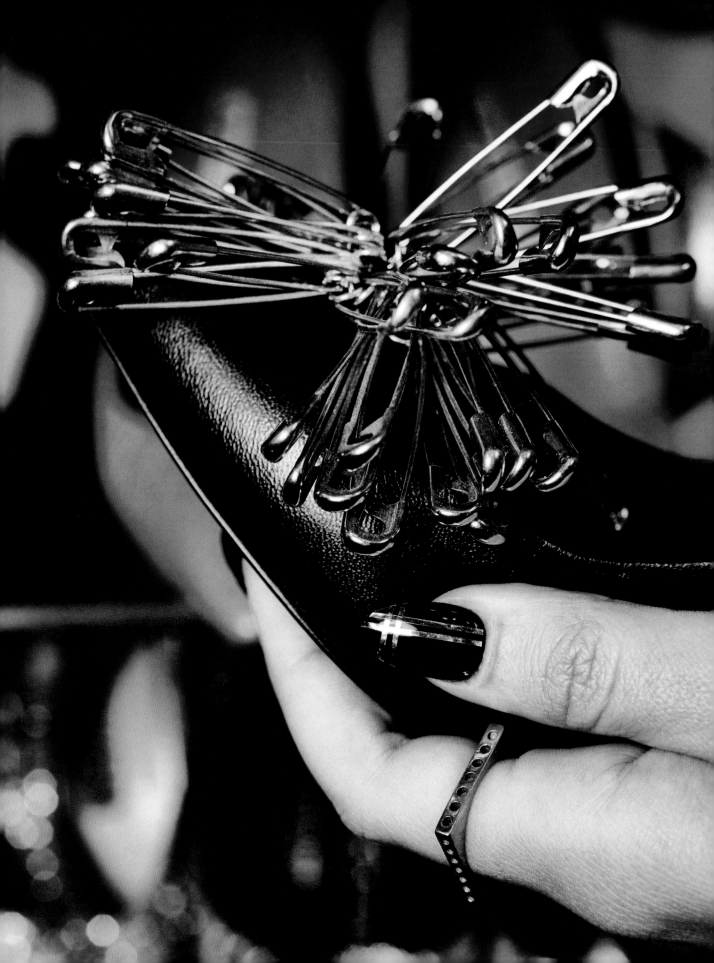

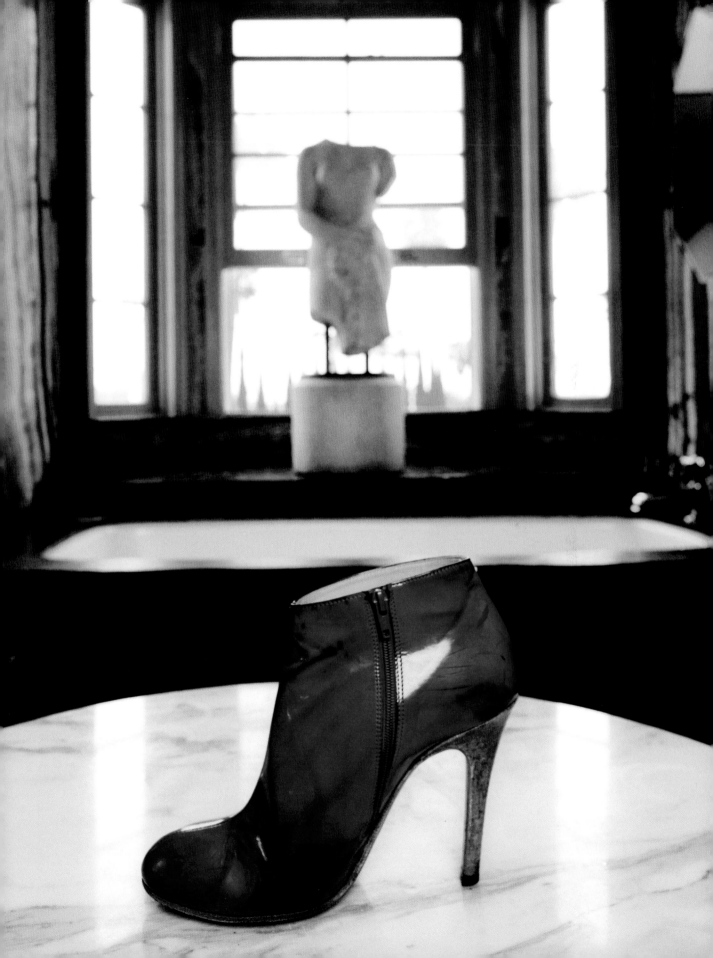

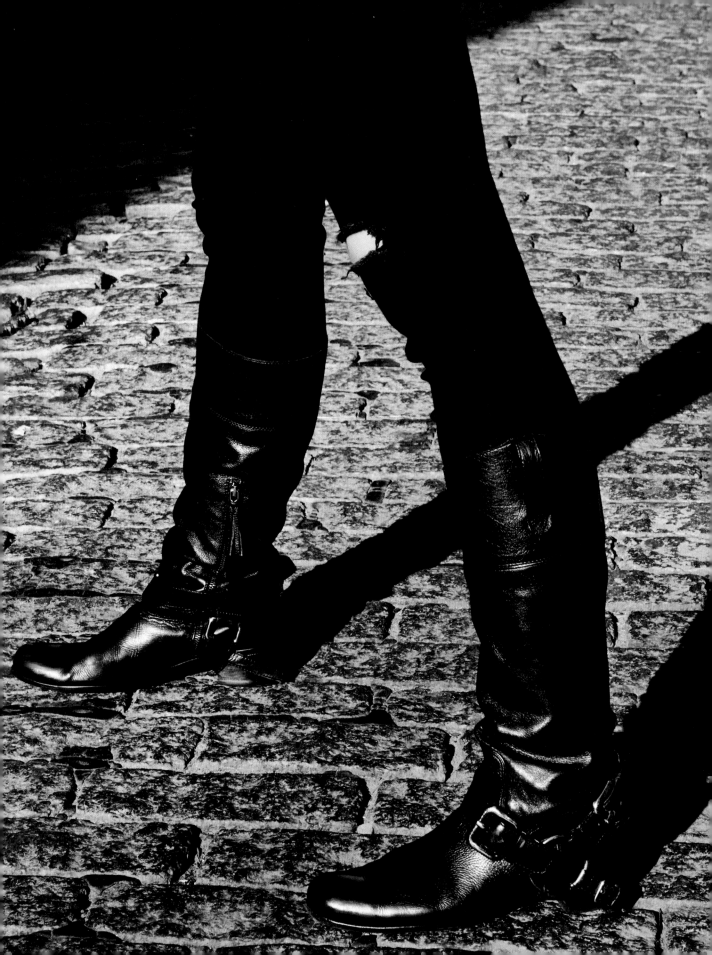

BRIDGET MOYNAHAN

AUTHOR, ACTRESS, & MODEL

I f I was going to narrow it down, the shoes that I always go back to, the shoes that are most comforting, the shoes that have the most meaning, are my black Miu Miu leather motorcycle boots.

Let me just say that most actors don't go into acting because they want to be famous. They go into it because they love acting. There is a certain amount of press required of you with projects, and that is all understandable. It's when your personal life becomes the main attraction that the attention and the press become unbearable.

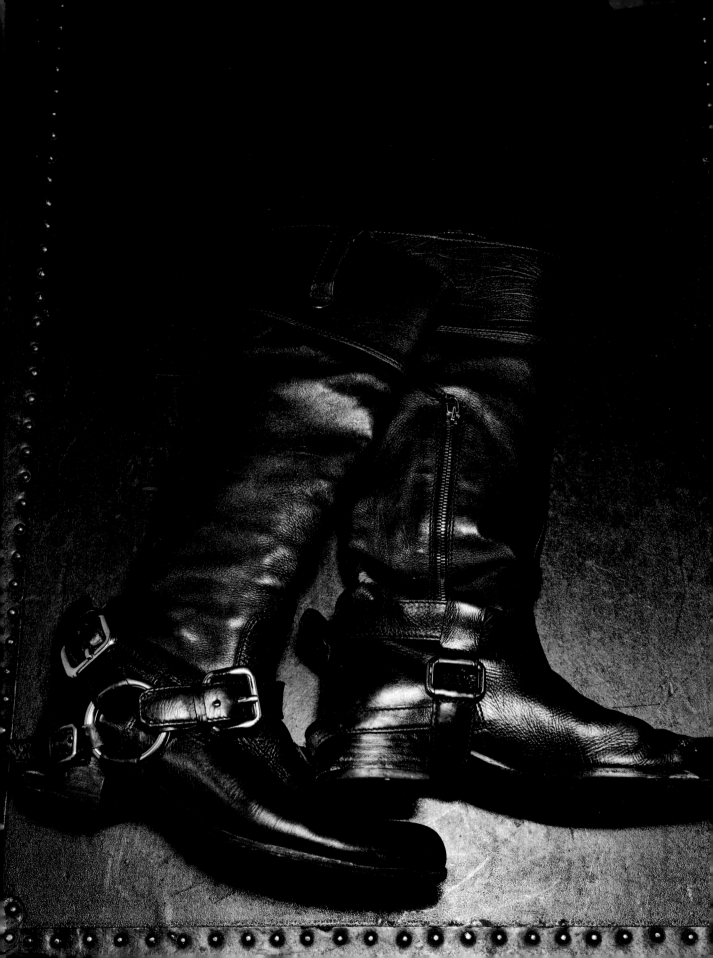

"I HAVE A CLOSETFUL OF GORGEOUS SHOES, BUT THESE BEAT-UP BOOTS ARE PERSONAL. THESE BOOTS ARE THE SECURITY BLANKET FOR MY FEET."

I was a single mom living in L.A. The year before, I had gone through a very public breakup with my boyfriend of three years, who happened to be a well-known professional athlete. His new girlfriend was a very successful model. As a result, between the three of us, the gossip mags were having a field day.

From the moment I announced I was pregnant to well after my son was born, the paparazzi relentlessly scrutinized me, documenting every pound gained, every trip to the doctor. Photographers armed with long-lens cameras would sit outside my modest, unassuming home trying to catch a glimpse of my son, desperate to capture his first photo. Teams of them would follow my car everywhere I went, in a caravan formation. Having a baby should have been the most joyous time of my life, but instead I felt assaulted. It's unnerving to be followed and stalked like that, especially during such an emotionally vulnerable time. This constant awareness that my privacy was being invaded, stolen from me and exploited, affected me deeply. I became reclusive for a bit, and I barely left my house. I became wildly private. I shared little and only with a select few.

It was late summer/early fall, which tends to be the best time to shop for a New England girl living in L.A. I was on a mission for the little man and had no intention of buying something for myself. I was off to the Grove to pick something up at the Baby Gap. I must have been naive to think that I could actually get there without a tail. Maybe I did, and I was just unfortunate to run into one of the many paparazzi that hang out at the mall to capture celebrities minding their own business. Who knows,

but I saw him and I tried to lose myself in the crowd. I went down one of the mall alleyways and found myself in a Barneys Co-op. I hid in there to kill some time before I abandoned my Baby Gap mission and could get back to my car. Being followed made me want to go back to the safety of my home immediately!

I wandered around the small shoe department, and that's when I saw them. I was staring at a pair of black leather Miu Miu motorcycle boots. They came to the knee and had leather and silver hardware wrapped around the ankles. They were strong. They were solid. They were badass and I needed them. I decided that these boots would give me back some of the confidence and strength that I had lost—lost from a very public breakup; lost from having a baby on my own; lost from two surgeries to correct hernias from having my baby; lost from not losing baby weight because the two surgeries kept me from recovering; lost from feeling incessantly violated by the paparazzi. I bought those boots and walked out of there feeling slightly closer to getting back to myself. It was a long road of learning what my new life would be like, and those boots have been on my feet every step of the way: play dates, auditions, screenings, dating, traveling, relationships, and parenthood, of course . . . The boots are not as beaten up as I was when I bought them, but they certainly have weathered over the years. I have a closetful of gorgeous shoes, but these beat-up boots are personal. These boots are the security blanket for my feet.

—*BRIDGET MOYNAHAN*

BRIDGET MOYNAHAN Bridget Moynahan is an actor, model, writer, and philanthropist. She got her start on *Sex and the City* and went on to star in films such as *Coyote Ugly*, *Sum of All Fears*, and *The Recruit*. Currently in her ninth season on the top-rated CBS show *Blue Bloods*, she is also the coauthor of *The Blue Bloods Cookbook*, a *New York Times* bestseller.

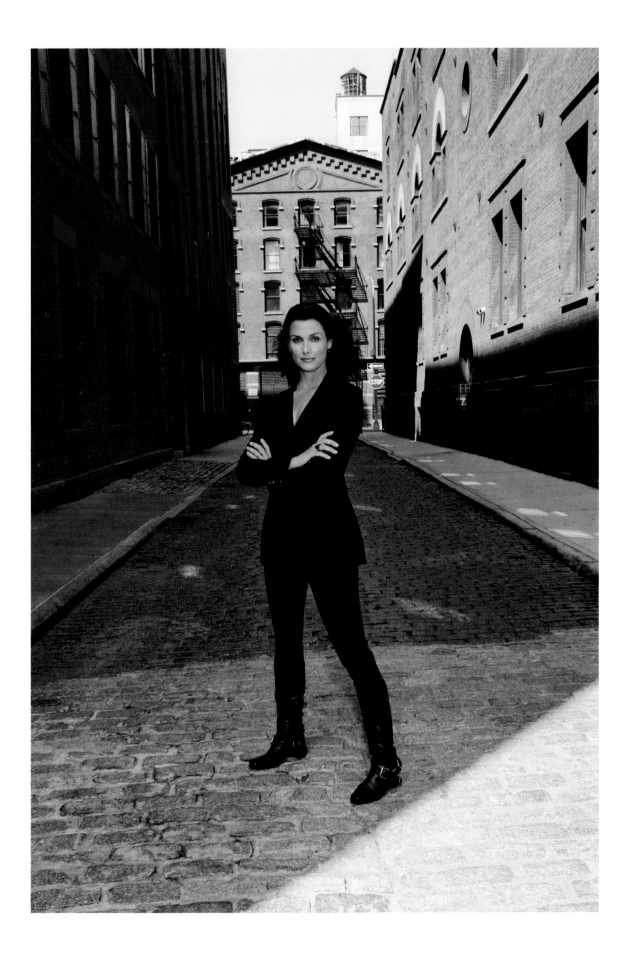

SENATOR PATTY MURRAY

UNITED STATES SENATOR, WASHINGTON

Back in 1988, I never envisioned myself sitting here in this seat as the third-highest Democrat in the United States Senate, the highest-ranking woman. I was just a mom at home taking care of my one-year-old and three-year-old.

I had enrolled them in a preschool program run through our community colleges. I brought them there one day, and the teacher said, "We're going to have to shut down the program because the state legislature just voted to defund it."

I thought, *This can't be.* So I put my kids in the car and drove one hundred miles to our state capitol in Olympia. I had never been there before, though I was born and raised in Washington.

I thought the state legislators needed to know what this program was, because I figured they didn't know what they had voted against. But everybody I talked to blamed everybody else.

Finally, one really nice state senator invited me into his office and said, "You know, that's a nice story, but you can't make a difference. You're just a mom in tennis shoes."

I was just astonished. Yes, that's who I was at the time, but did that mean that I didn't have a voice? That what I cared about didn't matter? So I drove home with my kids and said, "I am not going to let him get away with this."

I was mad. I was really mad. When I got home, I just started calling other parents who were in our program, and we all started organizing a drive to write letters to our legislators. Before you knew it, we had more than twelve thousand parents who were as mad as I was. They were all moms and dads—many in tennis shoes, too. They all felt their voices needed to be heard and that this program was important.

"I LEARNED THAT WHEN PEOPLE TELL YOU THAT YOU CAN'T MAKE A DIFFERENCE, IT'S USUALLY BECAUSE THEY'RE AFRAID YOU WILL."

Three months later, we organized a big rally in the state capital and brought all our kids, and, sure enough, the state legislators voted to reinstate the program. This had a huge impact on my life; I learned a lot about organizing, about getting involved, and about making a difference. I learned that when people tell you that you can't make a difference, it's usually because they're afraid you will.

From that experience—from me seeing how powerful ordinary voices could be—I said to myself, "I just can't sit at home and be quiet. I need to speak for all these other people whose voices aren't heard." After a little while, that drove me to run for office and keep doing exactly that kind of work.

To this day, people still identify me as the mom in tennis shoes, because I have told the story of what the state senator had said over and over to help people understand that they can make a difference too. Even today, people give me tennis shoes. I have tennis shoe earrings, I have a tennis shoe fly swatter. I can't go anywhere without people saying, "I so appreciate your tennis shoes story."

I had a consultant say to me once, "You need to ditch that mom-in-tennis-shoes image, you need to be seen as a powerful woman." And I said, "No. That is who I am." I've run for Senate five times and won, and I believe it's because people know who I am and I haven't changed. I still wear those tennis shoes as often as I can. It's actually my power zone, where I feel most comfortable, and reminds me of where I come from and who I am representing, and I get a lot more done when I'm wearing them.

—*AS TOLD TO AMANDA BENCHLEY*

SENATOR PATTY MURRAY Patty Murray is the first female senator from Washington State and currently the highest-ranking female woman in the Senate. After she was called a "mom in tennis shoes," she ran for state senator in 1988, defeating a two-term incumbent. She went on to the United States Senate in 1992, winning her sixth term in 2016. She is a ranking member of the Health, Education, Labor, and Pensions Committee.

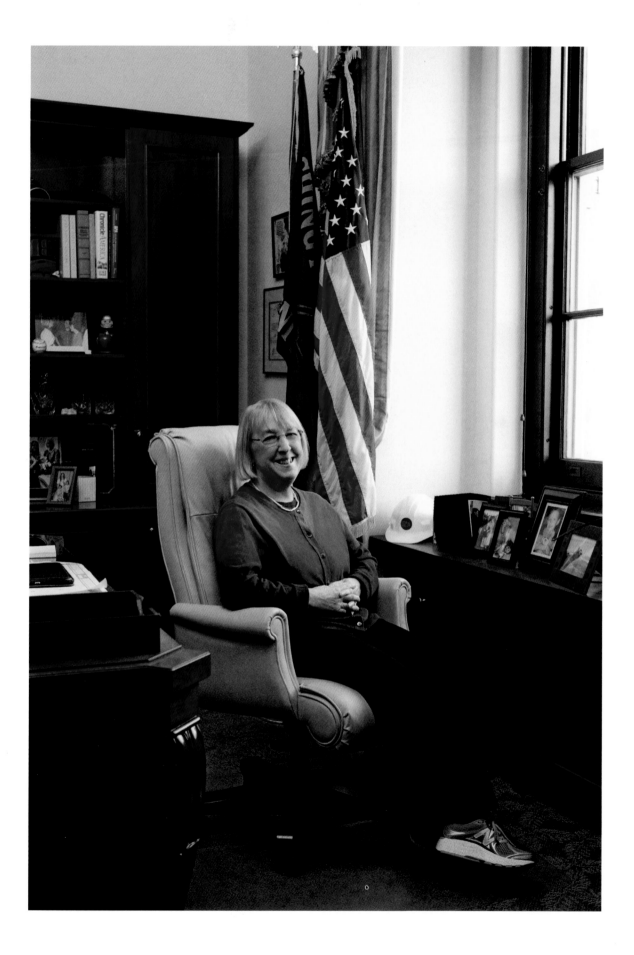

DANICA PATRICK

PROFESSIONAL RACE CAR DRIVER

I love shoes and have hundreds of pairs, but racing shoes are very different. They look kind of like wrestling shoes. They are soft and floppy and super comfortable but not very supportive, and they have heat-resistant elements in them. Sometimes there's extra padding on the side where your foot hits the throttle, because your foot can get sore being up against it during a race. They are as light as they can be, because it gets very hot when driving.

When you drive a race car, the design of the car is decided by the sponsor and the team. The same with the suit. So the only things I could change were my helmet, shoes, and gloves.

I've always been drawn to the flag and proud and grateful to be an American. I remember I once had a huge leather bomber jacket with the flag on the back and a swimsuit with an American flag on it. So I wore a helmet in patriotic red, white, and blue from the start, when I started racing at ten years old.

Back in 2016, around the Fourth of July, I thought I should have patriotic shoes made. When I changed into them, I thought: *Oh man, I should have always done this. They look really cool, unique, and different.* For the final race of my career, I got three

special pairs made. One shoe in each pair was imprinted with the year 2005 for the year of my first Indy 500 race, and the other had "2018" printed on it—the year of my last Indy 500 race. The three pairs looked exactly the same and were specific for Indy.

I only wore these shoes twice—the first time was for my final one-hour practice the day before the race. You always want to wear your shoes once before you race, just to make sure they're OK.

I remember putting on these shoes the next day for the 2018 Indy 500, my last race. It felt very normal but also very ceremonial. I felt like I was ready to transition and move on. When I took them off, I was sad because I'd had a bad day racing, but it was a relief at the same time.

My patriotic shoes are now in a storage unit with all of the other equipment and memorabilia from my career, including my very first firesuit. I really was ready to move forward in a different pair of shoes, a different kind of shoes.

—*AS TOLD TO AMANDA BENCHLEY*

DANICA PATRICK Danica Patrick started racing at age ten, when her parents bought her a go-kart. After winning numerous national go-kart titles, she transitioned at age sixteen to European road racing. In 2005, at age twenty-three, she finished fourth in her first Indianapolis 500, the first woman to score a top-five finish. In 2013, Danica was the first woman to win a NASCAR Cup Series pole and finished eighth in the race that year, the highest position ever for a woman in the "Great American Race." She retired from racing in 2018 and is pursuing a clothing line and a vineyard.

ROSIE PEREZ

ACTRESS, ACTIVIST, TALK SHOW HOST, & CHOREOGRAPHER

I was in the child welfare system for several years. My mother, who suffered from schizophrenia, put me in the system for no reason. Initially, I was placed in a children's home run by the Catholic Church, governed by the state of New York. It wasn't a good experience.

I got transferred out of the first institution to a group home, for the kids who were either academically or socially advanced and exhibited the potential to succeed in the "outside" world.

Throughout my time in the system, I was waiting for all the legalese to go back to my aunt Ana, who'd raised me as her own prior to my mother taking me from her and handing me over as a ward of the state of New York. Those years were more bitter than sweet.

One of the sweet parts was that I was able to go back to Brooklyn to my aunt's house on the weekends and for the holidays. However, there were several Christmases that I had to spend at the children's home, because my mother wouldn't authorize a visit to my aunt's, even though I loved Christmas at my aunt's house. I didn't love it at the home or the group home. Plus, I didn't fully believe in it—mainly because I didn't believe in Santa Claus.

Why would a saint give some kids gifts and some not, simply because they were poor? Even as a young child, it was very clear to me: There was no Santa Claus, and poor kids didn't get gifts like rich kids because of lack of money, plain and simple. So when the nuns would ask us to write to Santa, it would irritate me to no end. Why would I waste my time and risk further disappointment asking "Santa" for gifts that I knew I'd never get, especially in a Catholic charity for unwanted, displaced, or orphaned kids?

There was this one nun who asked me: "Please, please, please, just tell us one thing that you would really like to ask for." And I thought to myself: *I am going to tell them something really expensive that they'll never be able to give me.* I was a very precocious little girl, to say the least. So I asked for a pair of ice skates, a pair of expensive Riedell ice skates. I loved speed skating.

That Christmas morning, I opened up the box and there was a brand-new pair of pristine white Riedell ice skates. I couldn't believe it. I was so certain that the nuns didn't think I was happy or appreciative, because I was just quiet.

But I couldn't wait to get those ice skates on and go skating at the local pond. They meant so much to me. And it wasn't that all of a sudden I believed in Santa Claus. What I believed in was the spirit of giving.

The nun was named Sister Margaret Francis. I had so many negative encounters with the rest of the nuns from the Catholic charity, but she changed my life. She was different: She pushed me, she challenged me, and she supported me. She was the first of any of the nuns to tell me that I was an extremely intelligent girl and that I was going to be successful and the world was waiting for me. It blew me away.

The rest of the girls didn't like Sister Margaret Francis, but I did from day one. I just wouldn't show it much. She ended up falling in love with a man and leaving the convent, which broke my heart. But she came back to visit me when I was twelve years old.

I brought her a plate of cookies and a glass of milk while the girls were being rude to her. And she started crying. I didn't understand why—I thought it was because the other girls were disrespecting her.

She grabbed my arm and looked at me and said: "Put your head down and study as hard as possible and get out of here. With your mind and intelligence, education is your ticket out."

I said, "Okay." And she said: "No, promise me." And so I promised her.

I never threw those ice skates out. They have been with me for forty-plus years now. They're tight on my tiny feet, too tight to wear. They are bittersweet: They connect to a painful memory, but it's also a really positive and moving memory, because these skates represent hope and the real meaning of charity.

I keep them in a see-through airtight box that my husband got me. I had kept them in the original box, and we had a leak in our roof and the box got damaged by water. I got sooo upset, and my husband said: "It's just a box, why are you crying?" And I told him the story and he said, "Oh, sweetheart, wow, we need a waterproof box to put them in."

I had told him that I had had very few joyous moments while I was in the child welfare system and that these were my drop of joy.

ROSIE PEREZ Rosie Perez is an activist, producer, two-time-Emmy-nominated choreographer for *In Living Color*, and the director of *Yo Soy Boricua, Pa Que Tu Lo Sepas*. She is an Oscar- and Golden Globe–nominated actor for *Fearless*. Rosie is known for roles in such films as *Do the Right Thing*, *White Men Can't Jump*, and *Pineapple Express*, among many others.

RACHAEL RAY

TELEVISION PERSONALITY, CELEBRITY CHEF, & AUTHOR

When I'm at home, all I wear is sneakers or slippers, but for our show, I have to wear proper shoes. I have a pair of high-heeled Yves Saint Laurent short booties with metallic spots. They're called the Loulou—and they are comfortable enough that I can get through three shows a day in them, even with my wide "Frodo" feet! I absolutely love wearing them at work, even though they're the complete opposite of what I'd wear at home.

I'm not the only one who's worn the Loulou booties on our show. Every time Oprah comes to our set, I give her a basket of my favorite things—just like she used to do for her studio audience. In the fall of 2017, Oprah came to cohost our two thousandth episode, and I wanted to get her something extra-special for such a big milestone show, so I decided to get her a pair of the Loulou booties.

Before we started taping the episode, I went to Oprah's dressing room to say hello and give her the present. She was having some wardrobe trouble and had to change into a yellow leather skirt and black top—the exact colors of the booties I was giving to her. Once she'd changed, she opened up the package and realized they matched perfectly! She put them on and started dancing, and kept them on for the whole show.

"I HAVE A PAIR OF HIGH-HEELED YVES SAINT LAURENT SHORT BOOTIES WITH METALLIC SPOTS. THEY'RE CALLED THE LOULOU—AND THEY ARE COMFORTABLE ENOUGH THAT I CAN GET THROUGH THREE SHOWS A DAY IN THEM."

I'm still not sure how that happened, but it was like magic or kismet, which is kind of a nice metaphor for our friendship. I first appeared on *The Oprah Winfrey Show* in 2005, during my first book tour and after I had started on the Food Network. My flight to Chicago had been canceled and I cried, thinking I'd miss my appearance on her show. I ended up getting to my hotel room at 4 A.M. and stayed up all night to get my outfit ready for the show. Once on set, I was so nervous, but during my segment, she leaned in and said, "You are doing great. You've got it." I couldn't believe Oprah was encouraging me!

I was lucky enough to make multiple appearances on her show, and a year later, when my daytime talk show was in development, Oprah's company came on board as a producing partner. When we debuted in 2006, she was one of my first guests. I can't remember what shoes she wore that time, but I know I'll always be grateful for the role she's played in so many of my professional milestones and the incredible guidance she's given me, especially regarding philanthropy.

Oprah gave me an incredible piece of advice: to give back in a way that feels right to me and use what I love as a way to give back. I'm a cook, so I give back through food and with my cooking and kids' charity. I'm an animal lover, so I give back to animal rescue initiatives. While it's impossible to fill Oprah's shoes, I'm beyond grateful for the path she's forged and the opportunity to follow even somewhat in her footsteps.

RACHAEL RAY Rachael Ray won her first Emmy in 1996 with her first trailblazing show for the newly established Food Network. She then went on to win two more as Best Outstanding Talk Show Host for her syndicated show, *Rachael Ray*, which she launched in 2006. The author of more than twenty-five bestselling cookbooks, she has also developed product lines for furniture, cookware, and dog food.

GREGG RENFREW

ENTREPRENEUR

In 2014, my all-girls boarding school, Miss Porter's, asked me to speak at graduation. I had just launched my latest company, Beautycounter, and I think they wanted to highlight a woman who was successfully running a business that was empowering other women and effecting real change across the industry.

The school had meant so much to me as a young woman and had a significant impact on my life. I graduated in 1986, and I still remember the speech that Mpho Tutu, Desmond Tutu's daughter, gave about apartheid and the changes in inclusiveness that were happening in South Africa. I remember it like it was yesterday. I thought, well, I hope these young women will remember my speech for the rest of *their* lives. This is going to be a pivotal moment in time—graduation from a school that they love so much—when they're going to start shaping their futures. I need to leave them with some words of wisdom, to inspire them, and have some fun with it along the way.

The speech was the morning after my youngest daughter's preschool graduation in California. I then flew directly to New York, and didn't arrive in Connecticut until nearly 3 A.M. The speech was at 9 A.M. I got up early, got my hair blown out, and put

GREGG RENFREW | ENTREPRENEUR

on a navy striped dress (anyone who knows me knows I love a good stripe) and my favorite pair of blue patent-leather Jimmy Choo pumps. On the way over to campus, the little rubber tip of the heel tore off one of my pumps! I clanked on the pavement all the way to the school.

It wasn't ideal. I knew the speech was going to be broadcast live around the world and that so many prominent people would be in the audience. I started my speech by saying, "Look, I want you to know that I'm a little tired. Sometimes it's hard to do it all as a woman, but it is absolutely possible. You can be a great mom, a supportive wife, a powerhouse businesswoman, and an entrepreneur. You may not be able to have everything on the same day, but you can have it all, and don't let anyone tell you that you can't."

I also wove in some advice my mother had given me. She told me that you are like a cake, and, like a cake, you need to have a strong foundation, and that everything else in your life would be the icing. What she meant was that you always needed to be able to stand on your own two feet—to be financially independent, to have confidence in yourself—and that you could do whatever you set out to do. The "everything else"—marriage, children, business, or whatever else you want—is the icing. But you are the cake. I still use that metaphor when I give speeches.

It felt great. I came off the stage and was bombarded by students and parents and, later, by emails and letters thanking me.

I got the heel fixed and have worn those Jimmy Choos to almost every single important Beautycounter event to this day. I have had a lot of self-doubt, as many do, but getting up on that stage was a transformative moment. It was the beginning of my realizing the woman I had become, a leader with something to say.

—AS TOLD TO AMANDA BENCHLEY

GREGG RENFREW A natural and instinctive entrepreneur who sold her first company to Martha Stewart in 2001, Gregg Renfrew founded the skin-care and makeup company Beautycounter in 2011 with a mission to get safer beauty and personal care products into the hands of everyone. Renfrew has advocated for stronger federal regulations, specifically for the U.S. Food and Drug Administration (FDA), to ban the use of harmful ingredients in personal care products. She has spoken at *Vanity Fair*'s Founders Fair and *Fortune*'s Most Powerful Women NextGen Summit, as well as top business schools, including Wharton, Stanford, and Columbia.

CECILE RICHARDS

ACTIVIST & BESTSELLING AUTHOR

In 2015, I had been the head of Planned Parenthood for nine years. We were always under attack from somebody about something. But this was a particularly frightening and terrifying time—opponents of Planned Parenthood had gone undercover at our health clinics and illegally shot videos, which they were then splicing in ways to suggest the organization was breaking the law, which we were not. It was the worst, most nefarious fake-news campaign, and every week they would release another highly edited video with scary music.

There were five congressional committees investigating us, which is amazing because that's more than had investigated the 2001 Enron scandal or the financial crisis of 2008. And some politicians were using these videos as a way to create hysteria around the organization.

It became clear that they would probably call me to testify. I was hoping it would be a chance to talk to Congress about what we did and to clear up any misunderstandings. Of course, once I'd actually testified, I realized that it hadn't really been a hearing: It was more a public spectacle.

I had moved to Washington, D.C., to prepare for the hearing. I learned every single fact, from how many breast exams we provide in California to any other thing they could ask me.

I prepped for weeks with our attorneys. One of the things they wanted to check was my outfit, to be sure I looked "everywoman" enough. I wanted to wear a sensible navy-blue suit and an old pair of nondescript black shoes. But one attorney, a young woman, said, "Don't wear those shoes. They have a designer logo on them and the opposition might point that out." The shoes were quite utilitarian; I wasn't trying to make a fashion statement, I was just trying to do my job.

I had to call my husband in New York, because I didn't have all my clothes with me in Washington, and ask him to bring down my plain blue heels. I wasn't about to go out and buy brand-new shoes for this hearing. It never occurred to me that my audience wasn't only in Congress; it would include the millions of viewers watching. So the attorneys wanted me to look good, but not too good.

On the morning of the hearing, I steamed my clothes, called all three of my kids because, really, they're my best support system, and wore a pin of my mother's that looks like a sheriff's badge. I was nervous. I sat there at the table in the hearing room by myself, with dozens of TV cameras around. But I was prepared. I testified for more than five hours. But from the beginning it was clear that I knew more than the committee members about the subject matter and that this wasn't really a fact-finding mission. It was: How can we get this woman to squirm, and embarrass her? They were very angry, very finger-pointing, and I thought as long as I just remained calm, it would work out okay. It was really about their political posturing, and they just tried to poke at me. And the more they did, the calmer I got. One member of Congress acknowledged that they were trying to rattle me, and said, "You don't expect us to treat you differently just because you are a woman, do you?" And I said, "No, that's not how my mama raised me."

Finally, they ran out of questions; I think they just ran out of gas. It was such a relief. But it turned out that the hearing had been an opportunity to tell millions of people about the health care that Planned Parenthood provides to women around the country. Afterward, people would stop me on the street every day and say, "I watched that hearing. Thank you for what Planned Parenthood does."

I still think about that hearing when I put those shoes on. I found out later that our opponents were appalled that I wasn't wearing pantyhose, which they thought was a sign of disrespect. But that is the kind of scrutiny that women get for everything they do. It made me appreciate even more what women in Congress deal with every day.

—AS TOLD TO AMANDA BENCHLEY

CECILE RICHARDS Cecile Richards is the former president of Planned Parenthood, an organization that provides health services for more than 2.7 million women a year, the majority of which live below the poverty line. In 2015, an antiabortion group claimed that Planned Parenthood was selling fetal tissue—an accusation that Richards successfully refuted in Congress and which she discusses here. A former labor organizer, she is also the founder of America Votes and the Texas Freedom Network.

RONDA ROUSEY

PROFESSIONAL WRESTLER & ACTRESS

In 2010, I was twenty-three years old, broke, and living in Mar Vista, California, near Venice Beach. I was working three jobs—bartending, helping out at an animal rehab, and teaching judo—all while training full-time for MMA.

I used to sleep in the car, smashing my face on the steering wheel of my 2005 Honda Accord. She was gold and fabulous, and we called her Fonda Ronda's Honda.

I had a roommate who slept on the couch, and our food would come from Costco. We would eat frozen salmon patties with Sriracha sauce, and buy brown rice and broccoli in bulk, cook it in a wok that we found in an alley, and pour balsamic vinegar all over it. We would then watch movies. *Madagascar 2*, *21 Jump Street*—we had a whole book of DVDs.

At the time, I just wanted to find a job that I could enjoy and support myself with. There were no careers for women in fighting then. I didn't know it was even possible.

My mom gave me a fifty-dollar gift card for a store called Love Culture, a preteen girls' shop that my little sister liked, on Santa Monica Place.

So I went and there was a "buy one, get one free" offer happening on shoes. I saw the boots: They were soft faux suede, durable, and very easy to slip on and off. They

"ON FIGHT NIGHT, YOU ARE NOT SUPPOSED TO CARE HOW YOU LOOK. THESE SHOES HELP CONVEY THAT I AM HERE TO FOCUS ON FIGHTING."

were gray and went to below the knee, with a little silver buckle. They looked cheap as hell, and the fabric is now so worn I can't even get them repaired, but they are so goddamn comfortable.

Before a fight, I have this weird adrenaline response where I lose circulation in my feet and they turn yellow. So I always try to keep my feet warm before a fight with those boots.

I started wearing them to every single fight. I call them my Battle Boots. Everyone is required to wear certain shoes, like Reebok. Reebok was very cool about it and let me wear my battle boots. I don't wear them any other time, because they are so worn—they probably have only a mile left of walking in them, so I am trying to preserve them. The boots are wearing down at the speed of my body. My body is all worn out and bursting at the seams, and the boots are too.

I usually put them on a couple of hours before a fight, in the hotel room. I have my outfit to stay warmed up—my one outfit and my boots, which put me in that mind-set before a fight. With my Darth Maul hood and battle boots on, I look like Joan Jett, while the other girls are trying to be like Katy Perry. On fight night, you are not supposed to care how you look. These shoes help convey that I am here to focus on fighting.

I keep the boots under the stairs in my Venice house. When I travel, I carry them on the plane with me. Sometimes I have forgotten them and have to call someone to get them. We call that a "battle boot mission." I once had to have my sister break into my house to get them and bring them to Brazil for me. They really are that important.

—*AS TOLD TO AMANDA BENCHLEY*

RONDA ROUSEY Ronda Rousey was the first female fighter to be inducted into the UFC Hall of Fame in 2018. She first took up judo at the encouragement of her mother, who was a World Judo Champion. At seventeen, she was the youngest judoka in the 2004 Olympic Games and won a bronze at the 2008 Olympic Games—the first woman to medal in judo since it became an Olympic sport. Though the UFC had stated that women would never be allowed to fight, she made her mixed martial arts debut in 2010 and went on to become the first UFC Bantamweight Champion.

GRETCHEN RUBIN

BESTSELLING AUTHOR, BLOGGER, & SPEAKER

One truth about shoes? We can't avoid them. To deal with this fact, I wear running shoes.

I'm always wearing running shoes, or if I'm not, they're probably in the bag that I'm carrying with me, and they won't be off my feet for long—even at home. Many people prefer to go barefoot or wear slippers in the house, but not me. The minute I wake up, I put on running shoes, and I wear them as much as I possibly can until I get into bed.

I really dislike discomfort and making choices about what to wear, and the fact is, I'm really not very interested in shoes. So I love wearing the same pair of running shoes until I wear them out, and then buying exactly the same pair again (online, so I don't even have to go into a store). There's no decision fatigue.

However, I also do own a few pairs of "dressy" running shoes, which are slightly less comfortable and slightly more fashionable.

I get up at 6 A.M. every day to take my dog for a walk, and when I put on my running shoes, I don't even tie them—that's too much work! I just slip them on and off. After my dog and I return, I work for an hour, then I usually walk my daughter to school and take a long walk in Central Park. After that, I work more at home or at the library a block

away, or I go to the studio to record an episode of the *Happier* podcast. All while wearing running shoes! It's one of the great luxuries of my work life that I can wear running shoes, yoga pants, and a hoodie almost every day, and I never take that freedom for granted.

My mother often gently suggests, "Why don't you try wearing really comfortable flats or loafers?" Well, those shoes might be comfortable, but they're not as comfortable as running shoes.

My focus on comfort is also a consequence of the fact that I live in New York City. If I lived in Kansas City, where I grew up, comfort wouldn't be a concern. When my mother is in Kansas City, she can get in her car, drive someplace, and not worry about how far she'll have to walk. In New York City, I have to consider that I might end up walking three long avenues to get to the subway. Living in New York puts me at the mercy of my shoes, because I walk so much—which is one of my *favorite* aspects of living in New York City.

I published a book, *The Four Tendencies*, that describes a personality framework I devised that divides people into four types: Upholders, Questioners, Obligers, and Rebels. Rebels are people who resist outer and inner expectations, and one thing I learned from studying Rebels is that we're all freer than we think. For instance, on my book tour, I did wear real shoes—but now I realize that if I'd decided I was going to wear running shoes at every event, I could do that.

In my broader study of happiness, I've also learned this Secret of Adulthood: What's interesting and fun for *you* may not be interesting and fun for *me*—and vice versa. I feel like everybody is interested in shoes except me. But I don't have to be interested in shoes. To me, this realization is incredibly freeing.

GRETCHEN RUBIN Gretchen Rubin has rewritten the language we use to talk about the idea of happiness. The author of the groundbreaking 2009 #1 *New York Times* bestseller *The Happiness Project*, Rubin followed it up with three more bestsellers: *The Four Tendencies*, *Better Than Before*, and *Happier at Home*. Before turning to writing, Rubin was a successful lawyer who began her career as a law clerk for Supreme Court Justice Sandra Day O'Connor. She also hosts an award-winning podcast, *Happier with Gretchen Rubin*.

RESHMA SAUJANI

FOUNDER OF GIRLS WHO CODE

I n 2010, I was thirty-three years old and running for Congress. Up to that point, I felt I had done everything right—I had worked for the right companies, had the perfect résumé for that perfect job—and I'd never been so miserable. I was not doing what I thought I was meant to do. My family were refugees, and I had been wanting to serve since I was twelve years old. Instead, I was waking up and working in finance, which is the exact opposite of public service.

In 2008, I watched Hillary Clinton give her concession speech, and she spoke this line: "Just because I failed doesn't mean you shouldn't try too." I felt like she was speaking directly to me. So I decided to run for Congress. I ran in the New York City Democratic primary against Carolyn Maloney, who had been there for eighteen years.

I was the first Indian/South Asian woman to ever run for Congress. I had no previous political record, and the only thing my team knew how to do was build a website and raise $50,000 from the Indian community. Nobody could even pronounce my name! But it was amazing, because I didn't know any better. I thought I was going to win; I thought I could shake every hand, meet every voter.

At first, I was dressing how a thirty-three-year-old in 2010 dressed, in summer dresses and with sunglasses on my head. The reporters I met would only write about what I was wearing. So my consultants said, "Just don't wear anything that's worth writing about." All the political consultants in my life were trying to make me seem older. They told me not to wear dresses and to put on a boxy suit, glasses, and flat-heeled shoes instead.

I think when I started putting on a suit is when I stopped connecting in many ways. I was too busy worrying about what people thought of me and whether they were taking me seriously. Do I feel smart enough? Am I wearing the right outfits to make me seem like I am smart?

A couple of weeks before the election, we got a call from the *New York Times* asking if a reporter could follow me around for a day. I was just so excited that I put on a bright red dress and a pair of Kate Spade wedge shoes. Every woman who runs for office or who's on her feet in that way is constantly trading notes about what shoes you should wear. And one of my friends who had worked for Hillary Clinton told me, "You've got to get these Kate Spade shoes." So I got them, and they were amazing; you could last all day in them.

And that's when I realized that I should have worn the shoes the whole time, that authenticity mattered. For me, I wasn't comfortable wearing the boxy suit and the flat shoes. I wasn't myself; I wasn't able to connect. In my second race, in 2013, I was more me. I did dress in bright colors and wore my hair long. I think since then I have always been authentically myself.

That dedication helps me today in my work with Girls Who Code. I teach my girls to be themselves and to be fearless. To be brave—and part of being brave means being you, whether you want to wear a dress, pants, heels, or sneakers. Just be you. I think many of us think there's an image of what it means to be a powerful woman or change maker, and we decide to be someone other than ourselves. I think in this day and age you can smell inauthenticity in a second, and people don't connect. When I am feeling insecure or like I have to fit into some kind of mold, I come back and think about wearing those Kate Spade wedges that day.

—*AS TOLD TO AMANDA BENCHLEY*

RESHMA SAUJANI An attorney and activist, Reshma Saujani was the first Indian-American woman to run for the U.S. Congress in 2010, a time she reflects on here. She went on to found Girls Who Code, which has reached more than fifty thousand girls across the country. Her TED Talk, "Teach girls bravery not perfection," has more than three million views, and she is the author of two books, *Girls Who Code: Learn to Code and Change the World*, which debuted as a *New York Times* bestseller, and *Women Who Don't Wait in Line*. Reshma has also been named to *Fortune*'s 40 Under 40 List and *Forbes*'s Most Powerful Women Changing the World.

AMY
SHERALD

PAINTER

In the spring of 2016, the National Portrait Gallery, in Washington, D.C., was getting ready to commission an artist to paint Michelle Obama's official portrait. They sent a portfolio of my work to the White House along with other artists' for consideration.

Then I got a call that I had been short-listed, with five other artists, and the Obamas wanted me to come in for an interview. I couldn't believe it.

I had just won a competition at the National Portrait Gallery , but I didn't have a lot of money at the time. I was four months behind on my rent. My work was selling, but it can be feast or famine in the beginning of your career.

I was in Chicago for my first solo show, and my friend Dana's mother came up to me at the opening and asked, "So, what are you going to wear to the White House for your interview?" I was wearing the cutest outfit I had back then, which was some baby-blue culottes from Zara and some kind of floral top. I didn't even have any church clothes, because I don't go to church; I really didn't have a dress. I told her, "I think I'm going to wear exactly what I have on today." She said, "No, I'm going to take you shopping."

So we went shopping on the Magnificent Mile, and I was just looking at stuff and I really didn't know what to wear. I knew I wanted to be edgy and conservative at the same time. I wanted to feel like both—a little piece of my personality.

A saleswoman helped me put together an outfit. She chose a really beautiful mocha-colored dress with cap sleeves and a fishnet long-sleeved top underneath. I thought, *This is really cute, but now I need a pair of shoes.*

I was looking around and saw these little leopard-print kitten heels and thought, *I have to wear kitten heels because Michelle always wears kitten heels.* Dana's mom bought them for me.

I'd never had on a pair of kitten heels in my life. To me, they represented a world that I would never be a part of. I am an artist: I don't have to dress up to go to work; I

don't have to worry about blending in. They were a leopard print with a royal-blue reptile heel and sole, and I thought, *I want those*.

I felt really official in them. It was exhilarating to have them on, and when I walked into the White House, I felt like I belonged there. I held my back straighter and felt that I was supposed to be in the Oval Office, sitting with Michelle and Barack.

It was a magical moment. I walked in and I saw Michelle's shoes, and she was wearing kitten heels too. Barack walked up to me and said, "Looks like you got the memo." I was so nervous that I didn't understand his joke—that we were all wearing the same color that day. Michelle had on a dress that was two values darker than mine, and he had on a brownish-gray suit.

The meeting lasted about twenty-five minutes, but it felt like forever. We talked a lot about what I did outside my painting, like volunteering at the Baltimore city jail teaching art, and the community work I am interested in. Then we talked about my work. They had fully researched everything; they knew every detail, down to the fact that my sister helps me name my paintings. I could tell Michelle really liked my work, and I told her that I would very much like to paint her. And Barack said, "How would you paint me?" And Michelle had to jokingly remind him that the portrait would be of her.

I received the call that I'd been chosen for the portrait a couple of months later. I called my mom, and Dana and her mom, right away. Wearing those shoes had made me feel like the kind of person the Obamas would want to represent them, not just through the painting but also in life.

I haven't worn the shoes since. I look at them from time to time and try them on. I feel like I should wear them, but I also feel like I should put them in plastic and never touch them again.

—*AS TOLD TO AMANDA BENCHLEY*

AMY SHERALD Known for paintings that address the politics of race, Amy Sherald earned her MFA in painting from the Maryland Institute College of Art and was an artist-in-residence at Spelman College. Her paintings are in the collections of many museums and institutes, including the National Museum of Women in the Arts and the Smithsonian National Museum of African American History and Culture. The *New York Times* said that Sherald's portrait of Michelle Obama, which is in the National Portrait Gallery, "projects a rock-solid cool."

SUSAN SOLOMON

LAWYER & ENTREPRENEUR

Ever since my son was diagnosed in 1992 with Type 1 diabetes, I've been a passionate advocate for medical research. In 2005 it became my career. Frustrated by the slow progress toward a cure for diabetes and so many other diseases, I cofounded the New York Stem Cell Foundation. I wanted to learn how human diseases work in human cells rather than in animal cells, as was the standard of the time. Stem cell research was really under siege in those days, but we started in my apartment with four people: me and three others. When we got to six people, we thought, let's take the bold step of renting some space. We took a little space and worried: Could we afford it? Was it going to be too much?

In 2006, we opened a five-hundred-square-foot laboratory in an old academic research building. You didn't need to wear plastic booties, because we didn't, back then, have the sterile environment required for the most advanced research. We were just trying to understand how to use existing stem cells. It was a really early stage, before it became possible to make stem cells from skin and blood. It was like the dark ages compared with now.

Human embryonic stem cells were first isolated in the laboratory in 1998. Diabetes is incredibly difficult, because you have the double whammy of an autoimmune attack and the cells not producing insulin. But, in the early 2000s, we learned that we could make new cells that produce insulin. I remember talking to people at the New York chapter of the Juvenile Diabetes Foundation, telling them that stem cell research was going to be really important for our kids.

In 2004, California had launched a $3 billion state initiative for stem cell research, and I thought, *Let's try to launch one in New York*. A group of us eventually did get

191

something passed at the state level, in 2007, but it was much smaller: only $600 million. We needed to have a private organization to get this research going.

When we started, there weren't many people doing stem cell research. I'm an entrepreneur with a business background, and I was kind of nominated to do it and felt it was going to be a part-time thing. Then it became clear that the promise was huge. What I came to see pretty quickly is the value of having your own space where you can move very quickly. In a large institution or the government, you have to move slowly and balance priorities.

Twelve years later, in March 2017, we opened a very large stem cell research institute with forty thousand square feet and seventy employees. New York City's former mayor Michael Bloomberg was at the opening, and we all had to put on identical blue booties to enter the new lab with its advanced equipment and sterile environment. These booties became, for me, the footwear of empowerment, and the symbol of all the scientific progress we were making. They aren't what you would call fashionable shoes, but they give me a jolt of excitement that is as high as the sleek modern design of the lab. Every time I put those booties on, they remind me that I am walking into a laboratory that is actually having an impact for patients.

At the new lab, we are now able to make cells that can be put into patients, and we are starting clinical trials. The work we were doing in 2005 and the work we are doing now are just night and day. We can make stem cells from skin, from blood; we can edit them for specific diseases. We can build mini-brains and we can make the cells of our hearts that beat in the laboratory. We can make cells that can be used to create an avatar of an actual person. The first time I put on those booties, I felt like Superwoman. They brought tears to my eyes that day, and they still do.

SUSAN L. SOLOMON Susan L. Solomon is a lawyer, entrepreneur, and veteran health care advocate who is also the founder and chief executive officer of the New York Stem Cell Foundation Research Institute. Since its founding in 2005, NYSCF's stem cell research has accelerated progress in finding treatments and cures in more than seventy disease areas, including diabetes, ALS, multiple sclerosis, Parkinson's, Alzheimer's, heart disease, cancer, schizophrenia, bone injury, and macular degeneration. She has also won the New York State Women of Excellence award for her outstanding contributions to the health care world.

KATIE STAGLIANO

FOUNDER OF KATIE'S KROPS

In 2010, when I was twelve years old, I had the honor of being named a "garden crusader"—someone who has changed the world by gardening—for a contest sponsored by the Gardener's Supply Company.

At twelve years old I honestly was in no way an expert gardener, it was me just doing what I thought would be right, following my heart. I was a little girl with a big dream to end hunger, one vegetable garden at a time. With my parents supporting me and telling me that I could do anything I set my mind to, I started growing. I shared my harvest with local soup kitchens.

I had a garden at my house and one at my school, and I launched a fresh vegetable drive to help even more people. A wonderful man named Mr. Bob came to the drive. He told me that he had a John Deere tractor and that if I ever needed help tilling my garden I should call him. I did reach out to him, and I learned to drive a tractor at twelve years old. People lent gardening supplies and donated seeds, plants, and even money to help. My community was coming together and saying, "We believe in you and your dream and we are going to support you."

I remember being excited when I won the Garden Crusader contest, because it was an honor normally reserved for an adult. I was just a kid, and they believed in me and my dream to end hunger.

"I REMEMBER BEING EXCITED WHEN I WON THE GARDEN CRUSADER CONTEST, BECAUSE IT WAS AN HONOR NORMALLY RESERVED FOR AN ADULT. I WAS JUST A KID, AND THEY BELIEVED IN ME AND MY DREAM TO END HUNGER."

My prize was a $500 gift card. I went through the Gardener's Supply Company website and found some gardening tools for my gardens. But then my mom said, "You really need to invest in some actual shoes that you can wear to the garden that will not be destroyed in a couple of months." She was right. I usually wore my sneakers, which was not the best choice. I destroyed several pairs going into the gardens.

Then I saw my gardening boots—they were blue rubber with green and yellow pears on them—and I thought, *These are so cute, I need these boots.*

I wore my boots every single time I set foot in the garden, without fail—no matter what I was wearing with them, even if they looked super silly and didn't match at all. They saved me from countless fire ant bites and walked endless miles through the rows of my garden while I planted, harvested, weeded, and worked to put food on the tables of neighbors in need.

I wore my boots long after I technically outgrew them. Nothing I have found comes close to my bond with my pear boots. I wear long pants and Converse sneakers, which is a terrible idea. I've ruined numerous pairs of white Converse sneakers. And now as Katie's Krops continues to grow, I still haven't found a replacement pair of boots or other shoes that really reflect me.

KATIE STAGLIANO When Katie Stagliano was in third grade, she brought home a seedling for a cabbage, which she planted and let grow until it was forty pounds. She donated the cabbage to a local soup kitchen, which inspired her to start Katie's Krops, encouraging other kids and communities to grow vegetable gardens across her home state of South Carolina. She now oversees a hundred community gardens and runs Katie's Krops Dinners, all of which have helped feed thousands of people.

NINA
TANDON

BIOMEDICAL ENGINEER

When I decided to explore leaving academia in 2007, I bought a pair of plain black heels from a company called United Nude for my first big job interview. They're designed by Rem D. Koolhaas (the nephew of the architect) and are very nerdy and architectural, because they use a lot of negative space for the heel. Now they are basically the only label of shoes I ever wear.

I was a PhD student at Columbia, growing cardiac tissue in a lab, and I rarely had to dress up for work. I thought, *How do I look professional but still be authentic to myself as a bit of a geeky scientist?* There was something about these shoes that made me think: *These shoes are made of science.* I like these shoes because I am an engineer and their design plays with the idea of negative space. I love negative space; I love the unseen, the element of surprise. I feel like that idea resonates with my work. My work is about making the unseen seen, helping people discover that our bodies are made out of exquisite biological "technology" and naturally possess tremendous healing power.

The interview was for a summer associate job at McKinsey & Company, which was one of the first consulting firms to target PhDs, as opposed to solely MBAs. It was an amazing platform to launch my career as a scientist-entrepreneur. It was a time during which stem cells and health care in general were being hotly debated in politics. Pharmaceuticals and medical device companies were producing new classes of therapies

"I AM AN ENGINEER AND THEIR DESIGN PLAYS WITH THE IDEA OF NEGATIVE SPACE. I LOVE NEGATIVE SPACE; I LOVE THE UNSEEN, THE ELEMENT OF SURPRISE."

based on genetics. It was very clear to me that my work in the lab was related to the "real world" outside and that I didn't want to solely experience my scientific work from the perspective of inside the lab. I felt I should try to make a leap into the business world.

I wore a black-gray suit and these funky shoes to the interview. They happened to look very proper and goody-two-shoes from the front. The shoes were my little secret. I got the job.

At McKinsey, I learned that the business world wasn't just a glamorous place; it was a place where CEOs were trying to make decisions and figure things out just like the rest of us. McKinsey really valued us as contributors, and it was an amazing community of thoughtful, driven people. It was a huge learning experience for me. I think I wore those shoes almost every day.

That job at McKinsey helped me realize that I wanted to be a part of the business world, but not as a consultant helping guide strategy in large corporations, rather by rolling up my own sleeves, as an entrepreneur. It became clear to me while working there that so much of the most exciting innovation I saw was actually coming out of academic labs and small companies. I knew that someday I wanted to lead one of those small companies, and I knew that the way to do that was to go back to my science world first. I came back to academia knowing that I wanted to be a scientist-CEO. These shoes represent that transition and the journey I've been on.

—AS TOLD TO AMANDA BENCHLEY

NINA TANDON Nina Tandon is the CEO and cofounder of Epi-Bone, the world's first company growing human bones for anatomically precise, patient-specific bone tissue replacement and skeletal reconstruction. Using stem cells, EpiBone provides bone grafts that enable an exact repair and simplified surgery. She was named one of the most creative people in business by *Fast Company*, and her TED Talk on personalized medicine has more than one million views.

KELLY
WEARSTLER

INTERIOR DESIGNER

Ever since I was a young girl I have been drawn to design, and I knew early on I wanted to do something creative in the arts. My mother was a designer and took me to flea markets and auctions, which educated my eye from a young age. In addition to inspiring my love of design, my mother was a great role model for me with her strong work ethic and sense of independence. She always worked and set me up with a bank account and checkbook when I got my first job as a teenager. She taught me that there is no one who will take care of you better than yourself.

Throughout high school and college, I waited tables. It was a way for me to support myself and pay for school. It also helped me to become a serious multitasker. I went to Massachusetts College of Art in Boston and worked at this really cool restaurant on Newbury Street. I would go to class all day, come home and do an hour and a half of schoolwork, and then go to work. When I finished my shift around eleven o'clock at night, I would go home, shower, and then go to my studio space at school, where I would work until two o'clock in the morning.

After college I held a few design internships in New York City—including with Milton Glaser—before I made the move to the West Coast and started my design business in Los Angeles. After a couple of years—it was the mid-1990s—my business was taking off, and I had saved up enough money to go to Paris for a long weekend with a friend from college.

Paris was (and is) breathtaking: the architecture, the design, the museums, the people, the food. It was an incredible journey and experience for me. I had heard about

"I JUST FEEL SO ACCOMPLISHED IN THESE SHOES. THEY ARE SPECIAL TO ME BECAUSE THEY REMIND ME OF THAT MOMENT IN MY CAREER WHEN I FELT THE HARD WORK START TO PAY OFF."

how amazing the flea markets and the vintage shops were in Paris. I had a limited budget, but I am an excellent negotiator and wanted to bring back as many treasures as I could. I purchased two pieces of furniture for a client at one of the flea markets and was so nervous, as this was my first time buying pieces abroad and having them shipped back to L.A.

Once I finished shopping at the flea markets, I began exploring the vintage stores I had heard so much about. I found these incredible black-and-metallic shoes from the eighties by the Parisian brand JB Martin. I fell in love with them. They are sculptural and made of mixed materials, which I have such an affinity for. I love fashion, and it is a great inspiration for my design work and vice versa. I dress much the way I design interiors. I always combine something contemporary with something vintage, masculine with feminine, raw with refined.

I have worn these shoes to so many important meetings over the years. They travel with me everywhere I go, because they are the perfect height and are suitable for every season. I even wear them on construction sites.

I just feel so accomplished in these shoes. They are special to me because they remind me of that moment in my career when I felt the hard work start to pay off and the trajectory shift. I now go to Paris two or three times a year. Today, when I visit the flea markets, I know exactly how to make my way around, and it feels so good.

KELLY WEARSTLER A worldwide brand behind some of today's most stylish homes and hotels, Kelly Wearstler also runs a thriving, eponymous home design business, selling wares based on her signature looks and designs. She has been named to *Architectural Digest*'s Top 100 Architecture & Interior Design list, French *AD*'s World's Top Interior Designers, and *Wallpaper* magazine's Top 20 Designers. Wearstler served as a judge on Bravo's television competition series *Top Design*. She has also published four coffee-table books.

IN MEMORIAM: KATE SPADE

NOT ONLY WAS KATE SPADE an original participant in this project, but she was also one of its strongest supporters. In fact, a week before she died, she sent me an email about scheduling her portrait session. She wrote: "I am so proud of your book! Good job!"

Katy belongs in the pages of this book because she embodied so many of the same roles as the other women featured: entrepreneur; creative force; activist. She worked tirelessly as the board chair for the New York Center for Children, donated heavily to charities as varied as Planned Parenthood and the ASPCA, and was a hands-on volunteer at her daughter's school.

And though she became famous for handbags, she loved shoes. In our interview, she talked about walking into Bergdorf's and seeing a pair of gold platform Yves Saint Laurent shoes that she had to have, even though, as she explained, "They are so NOT me." But part of her reason for buying them was that she no longer worked for her namesake company and felt that she was now free to wear whatever type of shoes she wanted. And she did wear those fabulous, sexy YSL platforms often—and revealed the indented toe marks to prove it!

Katy loved those shoes because they were out of her famously preppy, conservative comfort zone. But she also loved them because she was in the shoe business and appreciated their engineering. Holding the shoes in her hand, she pointed out the details of their well-designed structure: the tilt of the foot bed, why the heel was that height, the choice of material. She laughed as she showed me, making fun of her geeky "shoe language."

Katy laughed all the time. I first met her over ten years ago when she was winding down her time at the company that bore her name. I admired a Kate Spade alligator bag that she was carrying and asked if it was still in the stores. The next morning, it appeared at my front door, festooned with ribbons and a hand-written note (always).

Last year, I mentioned that I loved a pair of strappy velvet high heels from Frances Valentine, her latest company. She offered to send them to me, which I refused, saying I wanted to support this new venture. Of course, she sent them to me anyway, along with a pair of sparkly, sequined slippers and mules with a feathered toe. Because that's who she was. She loved beauty and whimsy and fun and her friends. I would argue that those six-inch high, properly made gold YSL platform shoes were, in fact, SO her.

—AMANDA BENCHLEY

CHARITY INDEX

A portion of the author proceeds from *Our Shoes, Our Selves* will be dedicated to Girls Inc., which serves girls ages six through eighteen and focuses on the development of the "whole girl" by providing mentoring relationships, a pro-girl environment, and programming to lead fulfilling and productive lives and break the cycle of poverty. Many of the outstanding women profiled in these pages have beloved charities of their own, and we would like to honor them and their charities by listing them below.

UMBER AHMAD

No Kid Hungry was launched in 2010 by Share Our Strength to help find the best approaches to eradicating poverty and hunger.
www.nokindhungry.org

CHRISTIANE AMANPOUR

The Committee to Protect Journalists and the IWMF (International Women's Media Foundation) protect press freedoms worldwide. Pepo La Tumaini provides education and health care to women and children affected by HIV.
cpj.org/about; www.iwmf.org; www.pepolatumaini.org

CHLOE X HALLE BAILEY

Through impactful dynamic partnerships, BeyGOOD's mission is to set an example of giving back and paying it forward while empowering others to do the same with what they have in their own communities. BeyGOOD is built on the belief that we are all in this together and each and every one of us can make a difference by giving back.
www.beyonce.com/beygood

BOBBI BROWN

Girls Inc.
www.girlsinc.org

CHRISTY TURLINGTON BURNS

Every day, eight hundred women will not survive pregnancy and childbirth, and thousands more will suffer from long-term disabilities. Every Mother Counts provides basic and life-saving maternity care to prevent these outcomes.
www.everymothercounts.org

BARBARA BUSH

The Barbara Bush Foundation for Family Literacy advocates and establishes literacy in every home.
www.barbarabush.org

EILEEN COLLINS

The Fresh Air Fund has provided nearly two million New York City children with the opportunity to experience outdoor summer adventures through visits with volunteer host families.
www.freshair.org

MISTY COPELAND
American Ballet Theater's
Project Pile is a comprehensive
initiative to increase racial and ethnic
representation in ballet and to
diversify America's ballet companies.
www. Abt.org/community/
diversity-inclusion/project-pile

KATIE COURIC
Stand Up to Cancer funds the newest
and most promising cancer treatments
to help cancer patients now.
www.standuptocancer.org

STACEY CUNNINGHAM
Team Wilderness uses outdoor summer
excursions to help build character and
teamwork in urban youths.
www.teamwilderness.org

WENDY DAVIS
Deeds Not Words turns ideas about
women's equality into action, providing the
tools to make changes in the community.
www.deedsnotwords.com

KATE DICAMILLO
Kate DiCamillo wholeheartedly and
passionately supports local public libraries.

GEN. ANN DUNWOODY
Special Operations Warrior
Foundation provides immediate financial
grants to severely combat-wounded
and hospitalized Special Operations
personnel and their families.
www.specialops.org

SYLVIA EARLE
Mission Blue inspires actions to explore
and protect our endangered oceans.
www.mission-blue.org

CINDY ECKERT
Vital Voices invests in women leaders
who have a daring vision to expand
their skills, connections, and visibility to
make that dream a reality.
www.vitalvoices.org

DR. MAE JEMISON
The Dorothy Jemison Foundation
for Excellence develops and implements
teaching methods, curricula, materials,
and programs, with special emphasis on
building critical thinking skills.
www.jemisonfoundation.org

RUPI KAUR
TRCC/MWAR is a grassroots women and
non-binary collective working toward
a violence-free world by providing feminist
peer support.
www.trccmwar.ca

PADMA LAKSHMI
Shanti Bhavan empowers children from
India's lowest socioeconomic class to break
the cycle of generational poverty through
education, health care, and compassion.
www.shantibhavanchildren.org

LAUREN BUSH LAUREN

FEED Projects creates good projects—
leather and canvas bags and accessories—
that help feed the world.
www.feedproject.org

MAYA LIN

What Is Missing? Foundation raises
awareness about species loss and
emphasizes that protecting and restoring
habitats can both protect species
and reduce carbon awareness.
www.whatismissing.net

DEBORAH LIPSTADT

The ML4 Foundation funds and promotes
medical research dedicated to developing
treatments and a cure for ML4, a genetic
disease that causes developmental
delays, gross and small motor functions,
and a limited life span.
www.ml4.org

SARAH MCBRIDE

Planned Parenthood of Delaware
has served women, men, and families for
more than eighty years, promoting
reproductive and sexual health through
education, counseling, and medical services.
www.plannedparenthood.org/
planned-parenthood-delaware

BRIDGET MOYNAHAN

Hole in the Wall Gang provides a
"different kind of healing" to more than
twenty thousand seriously ill children
and family members annually free of
charge. Jumpstart provides language,
literacy, and social-emotional
programming for preschool children and
promotes quality early learning for all.
www.holeinthewallgang.org;
www.jstart.org

DANICA PATRICK

Rescue Ranch promotes respect
for all animals as well as all varieties of
wildlife conservation and rehabilitations.
www.rescueranch.com

ROSIE PEREZ

Urban Arts Partnership takes an
arts-integrated approach to education
in and beyond the classroom—an
approach that has improved academic
outcomes and graduation rates as
well as artistic growth.
www.urbanarts.org

RACHAEL RAY

Yum-o! educates kids and their
families about food and cooking by
enabling young cooks to get started
in the kitchen with family-friendly
recipes and teams up with partner
organizations to feed hungry children.
http://yum-o.org

GREGG RENFREW
Save the Children gives children a healthy start in life, through opportunities to learn, and protects them from harm.
www.savethechildren.org

CECILE RICHARDS
Planned Parenthood provides comprehensive reproductive and complimentary health care services in settings that preserve and protect the privacy and rights of each individual.
www.plannedparenthood.org

RONDA ROUSEY
The Didi Hirsch Foundation provides quality mental health and substance abuse services in communities where stigma or poverty limits access.
www.didihirsch.org

GRETCHEN RUBIN
The New York Public Library has been an essential provider of free books, information, ideas, and education for all New Yorkers for a hundred years.
www.nypl.org/support/donate

RESHMA SAUJANI
Girls Who Code was founded with a single mission: to close the gender gap in technology.
www.girlswhocode.com

AMY SHERALD
Harboring Hearts provides critical financial and emotional assistance for heart patients and their families.
http://harboringhearts.org

SUSAN SOLOMON
The New York Stem Cell Foundation has created foundational tools for using stem cells in basic research, but also pioneers technology that will allow stem cells to be used therapeutically.
www.nyscf.org

KATIE STAGLIANO
Katie's Krops empowers youth to start and maintain vegetable gardens and donate the harvest to help feed people in need and to assist and inspire others to do the same.
http://katieskrops.com

NINA TANDON
Kiva provides loans that change lives, connecting people and alleviating poverty internationally.
www.kiva.org/about

KELLY WEARSTLER
St. Jude Children's Research Hospital advances cures and means of prevention for pediatric catastrophic diseases through research and treatment.
www.stjude.org

ACKNOWLEDGMENTS

I want to thank you, Amanda, for not only believing in this idea from the start but also encouraging me daily that we could make this a reality. Imagine what we could have done if you had called me nine years ago! My agent Brad Slater, for always believing in me and helping make this come to life. My agent Maury Dimauro, who had me at day one. My manager, Andrea Pett Joseph, for being the "rainmaker." Molly, my right hand, my left hand, my IT Genius, I can't do anything without you. My publicists, Christina Popadopolous and Gary Mantoosh . . . you guys are always in my court. Greg and Aaron, for keeping it all straight! To all of my girlfriends, thank you for your support, love, and suggestions of incredible women to highlight. The list is endless, and there will never be enough pages.

A special thank-you to my husband, Andrew, for your love, support, and patience throughout this project. You are a godsend! Finally, my son, Jack, and stepsons, JB, Griffin, and Jack, who ate many meals surrounded by notes, essays, lists, and shoes. The organized chaos paid off!

—**BM**

Thank you to Bridget for being the best partner imaginable. Your research and curation for our dream list was uncompromising, and you fiercely insisted that each woman was truly worthy of being in these pages and a role model in her own way. You kept us focused and inspired me with your work ethic, high standards, and dedication to making sure our message was loud, strong, and clear.

I want to thank the other women in my life, too—from Eloise, my brilliant, beautiful firecracker of a daughter, to my brave, strong niece, Annabel, to my sister, Kara, who always tells it to me straight. So much love to my beloved friends, who are as selectively chosen as the participants in this book. And huge hug and thanks to Teddy Benchley and the other supportive men in my life, who really "got" this project even if it wasn't in their immediate wheelhouse.

—**AMB**

We would also like to give special thanks to Melanie Dunea for her fantastic photographs and intrepid spirit, as well as Rebecca Kaplan, Emily Wardwell, and the whole team at Abrams. And thank you to all of the following who reached out on our behalf and believed in this book:

Beckie+Martina, Ray Brown, Roger Cabello, Maureen Cavanagh, Brenda Colon, Lisa Frelinghuysen, Gretchen Gunlocke Fenton, Girls Inc., Emily and Andy Gershon, Kelcy Griffin, Tony Germano of Germano Studios, Lori Hamlin Penske, Sharon Coplan Hurowitz, Hannah Kronholm, Janina Lee, Karen Mehiel, Julie Pershan, Amy Richards, Liz Robbins, Deedie Rose, Lela Rose, Maria Salandra, Emily Shapiro, Gilda Squire, and Jay Stradwick of Dune Studios NYC.

This book wouldn't have been possible without you and the wonderful women who shared their shoes and their stories. May everyone keep forging his or her own footprints!

Editor: Rebecca Kaplan
Designer: Emily Wardwell
Production Manager: Denise LaCongo

Library of Congress Control Number:
2018936275

ISBN: 978-1-4197-3453-3
eISBN: 978-1-68335-508-3

Printed and bound in the USA
10 9 8 7 6 5 4 3 2 1

Abrams books are available at special
discounts when purchased in quantity for
premiums and promotions as well as
fundraising or educational use. Special editions
can also be created to specification. For
details, contact specialsales@abramsbooks.com
or the address below.

ABRAMS The Art of Books
195 Broadway, New York, NY 10007
abramsbooks.com